VIDEOTEXTS

Peggy Gale

Published for The Power Plant – Contemporary
Art Gallery at Harbourfront Centre by
Wilfrid Laurier University Press

Canadian Cataloguing in Publication Data

Gale, Peggy, 1944-
 Videotexts

Includes index.
ISBN 0-88920-252-4

1. Video art – Canada. I. Title.

N6545.5.V53G35 1995 702′.8′10971 C94-932699-2

The Power Plant – Contemporary Art Gallery
at Harbourfront Centre
Toronto, Ontario, Canada

Cover design by Jose Martucci, Design Communications,
using images by Lisa Steele, *Juggling*, 1972
(courtesy of VTape, Toronto)

Printed in Canada

Videotexts has been produced from a manuscript supplied in electronic form by
the author.

CONTENTS

Acknowledgements

Special thanks to Karen Mac Cormack for her suggestions and recommendations in the preparation of these essays for publication.

These texts have appeared in earlier versions as noted:

"Video Has Captured Our Imagination," *Parachute* 7 (Summer 1977), and *In Video* (Halifax: Dalhousie Art Gallery, 1977).

"To Tell the Truth: Narrative and Fiction in Artists' Video," *Texts* 9 (Winter 1993).

"Narratives," *Parachute* 41 (December 1985), and also *Video by Artists 2*, ed. Elke Town (Toronto: Art Metropole, 1986).

"Memory Work," *Descant* 60, 19, 1 (Spring 1988).

"Learning to See," in *Norman Cohn: Portraits* (Toronto: Art Gallery of Ontario, 1984).

"The Use of the Self to Structure Narrative," in *Western Front: Vidéo* (Montreal: Musée d'art contemporain, 1984).

"The Problem of Description," in René Payant, ed., *Vidéo* (Montreal: Artextes, 1986).

"A Tableau Vivant," *Parachute* 39 (June 1985).

"Another Kind of Anthropology," *Parachute* 62 (Spring 1991).

"There's Something Perverse about This Relationship," *Parachute* 58 (Spring 1990).

"A History in Four Moments," in Janine Marchessault, ed., *Mirror Machine: Video and Identity* (Toronto: YYZ Books; Montreal: CRCCII [Centre for Research on Canadian Cultural Industries and Institutions, McGill University], 1995).

The Power Plant wishes to acknowledge the financial assistance of the Canada Council in the publication of this book.

INTRODUCTION

Videotexts considers issues in contemporary art and media, bringing together essays centred on artists' video in Canada. The business of electronic recording itself—what machines do—is not my main concern. As far as the artists and tapes and installation pieces and ideas considered here are concerned, I am more intrigued by conceptual initiatives, ways of working, and challenges to perception. The movement towards narrative is a special interest: narratives of many sorts, including those which may dispense with words. Narrative is a means to *construct meaning* and to *confirm memory*, spurred on by intimation and implication.

The first artists' video appeared in the late 1960s and early 1970s as a response to what might be done with the newly available small-format portable video cameras—this new consumer item, with its grainy image that (unlike film) needed no developing. Instant. And pretty cheap. Travelling light.

The works discussed here are paradigms, roadsigns and charts focussing particularly on the first generation of video production as it was developed over a two-decade span. Most of these essays were written in the mid-1980s, and have been reworked here to remove overlaps and, in some cases, to furnish current figures or additional, recent examples. The opening essay sketches a brief history for artists' video in Canada since the early 1970s; each of four "moments" is characterized by its prime invention, its defining development or concern. The second essay, a landmark statement originally published in 1977, has been significantly rewritten and updated, addressing the charge that early video was "boring"; the text queries real meanings for so loaded a term, for audiences both general and particular. Figures for television and cinema attendance and the im-

1

pact of video playback via VCR at home, are all collected as underlay to a discussion of entertainment and popular appeal. A first investigation of "narrative" is made in "To Tell the Truth," as the place of honesty, accuracy and relevance of representation is sought in video's use of fiction and autobiography. Other inventions, both formal and literary, are discussed in "Narratives," with General Idea's videotape *Cornucopia* as a point of departure. "Memory Work," which follows, probes the function and importance of *time* in video viewing and production, with dreams and memories and the role of language brought forward for discussion. "Identifying Codes/Learning to See" returns yet again to narrative issues, attempting to define a *nonverbal* form of logic and communication. "The Use of the Self to Structure Narrative," coming next, considers videotapes from 1979 by Kate Craig, Elizabeth Chitty and Susan Britton for a discussion of the wilful positioning of the body of author as performer in artists' video from that period. Women played a crucial role in the development of video's language and concerns throughout the 1970s, and this essay draws attention to the acuteness of certain psychological and political statements being proposed by women at that moment. "The Problem of Description" then underscores the impossibility of *translation* in media, and looks at the place of contextual codes in furnishing meaning. The essay titled "A Tableau Vivant" introduces video-related installations, and summarizes their advantages and problems for institution and audience. While the economic and aesthetic climate of the 1980s made the scale and glamour of media-based installation works especially appealing, referenced to substantial sculpture and architecture as they were, such pieces proved hardly affordable for the decade that followed; by comparison with the earlier moment of ambition and excitement, there were to be fewer new installation works realized in the 1990s, and artists returned to a personal scale and more private concerns with little apparent regret. In "Another Kind of Anthropology," tapes by Robert Morin and Lorraine Dufour are discussed for their illumination of contemporary culture through creative fictionalizing in documentary-style work, and the final essay on *Exclusive Memory* and re-

lated projects by Tom Sherman looks more closely at the place of fiction in narrative structures.

In each case, it is intended that a remarkable single work open up an entire area for consideration, though inevitably it is tempting to double the list, to invoke hindsight and discuss many additional pieces in studies of greater depth. It is difficult to consider any collection "finished" enough.

Would it be fruitful, for example, to draw comparisons between the search-for-roots in a newly discovered homeland — the China of Paul Wong (in *Ordinary Shadows, Chinese Shade* [1987]) and Richard Fung (in *The Way to My Father's Village* [1988]) or the Trinidad of Fung's *My Mother's Place* (1990)? We could accompany Gitanjali to India in *New View, New Eyes* (1993) as she seeks out her family heritage. These tapes are directly in line with the more local self-study of the early 1970s, which capitalized on video's portability and its instant record/playback. One could wish to look into the "anti-commercial" *TV Spots* (1988) of Stan Douglas, or his minimum-quotient scale of inclusion for the *Monodramas* (1991). Douglas' comment on the traditions of commercial television is analogous to some extent with the play on "found formats" by General Idea or Vera Frenkel which are included here, different though those results might be. *Continuons le combat* (1971) by Pierre Falardeau is an "anthropological" study, in this case of Québec society in the aftermath of the October Crisis — not unrelated to *La femme étrangère* (1988) by Robert Morin and Lorraine Dufour discussed here, in its understanding of the social fabric and implications for the individual. The collaboratively produced docudramas of Igloolik Isuma Productions or Lisa Steele and Kim Tomczak want discussion, too, for their further development of dramatic narrative into the 1990s. There is no end to material worth investigating or reviewing, though a finite range is presented here. To an important degree these essays represent a present-tense response to artists' ideas and processes *as they were unfolding*, and that quality of "first-hand witness" is already vanishing with more recent developments. The moment remains here, then, for the record.

Videotexts grew out of my own attempts in the 1970s to understand the specifics of the new video medium — an attempt to understand why and how it was different from film, but also from "regular" television, and how it related to work being done by visual artists in other media. The fact that a camera and monitor were involved was obvious, but not necessarily the primary factor in video's evolution and impact. In the early days much video was adamant about NOT being TV; indeed, many of those early practitioners (in Canada at least) considered their work more allied to *sculpture* than to film or painting. There was also something about the physical presence of that box-emanating-light that made it for many artists a receptive conduit, an invitation to diaristic or confessional material. While in the United States it became common to seek out the *unique properties* of this electronic medium, in Canada video's relationship to the *mirror* and its facility for recording words seemed more significant priorities. Narrative and various plays on dramatic content seemed quickly to grow from these qualities. In the early days at least, the history and presence of *film* — both commercial and experimental — were considered quite irrelevant to video by Canadian artists working with the new medium. The earliest critical writing published about the video medium came from the United States and reflected the assumptions of cinema. In considering the videotapes being produced by artists in Canada — their intention and result — what was being written in the early 1970s seemed doubly inaccurate.

An overview leaves out many particulars, and sketches a summary history of highlights, where choices are made for reasons not necessarily conscious or intended. Agendas will differ for any artist, curator or audience member — and a wide variety of perception/response is always to be found if honestly sought. The fact that none of this video work by artists has found a commercial sponsor, and little of it an audience via broadcast television, makes a discussion of its aims and character in print all the more timely. As "art" its concerns are almost certainly incompatible with the exigencies of advertising. Commercial appeal, in any case, is a red herring for the reception of intellectual and

aesthetic accomplishment. It is only the "television-look" of the video monitor that has confused reception of the two forms.

There are partial histories included here from several points of view, along with a discussion of video installation and the play of personal performance and memory in the medium generally. One may ascertain the intellectual terrain at stake, the means of proceeding both practically and conceptually. It is to be hoped that the discussion of these few titles opens doors to work from any number of environments.

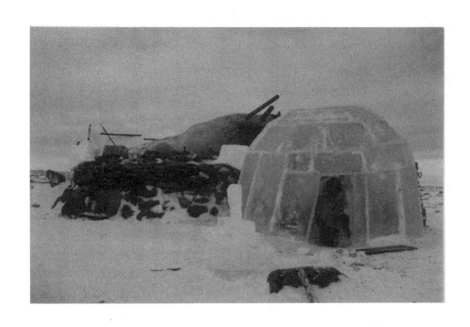

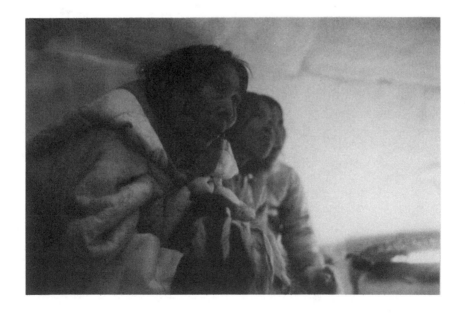

1

A History in Four Moments

For this history of video in Canada, each of the four sections identifies a prevailing characteristic of its moment, as seen from the mid-1990s. While there are numerous other roads crossing the same terrain,[1] perhaps a map as *simple* as this one can offer clarity.

Central issues for artists in English Canada have been conceptual, narrative, dramatic and social concerns, each in turn. A history of francophone work incorporates similar headings, but in altered order and to different ends, of which more later.

A "Conceptual" Base

Artists' use of small-format video appeared alongside — and under the influence of — the Conceptual Art of the late 1960s and early 1970s, as the visual arts turned away from the commercial gallery/museum/dealer/collector systems that had been so central to the postwar art market of Europe and America. Sol Lewitt, writing in *Artforum* in 1967, outlined the term, affirming that

Opposite page above: Production still from *Qamaq* (*Stone House*), 1993, by Zacharias Kunuk, Igloolik Isuma Productions. Photo courtesy of the artist.
Opposite page below: Production still from *Qaggiq* (*Gathering Place*), 1989, by Zacharias Kunuk, Igloolik Isuma Productions. Photo courtesy of the artist.

> In conceptual art the idea or concept is the most important aspect of the work. When an artist uses a conceptual form of art it means that all the planning and decisions are made beforehand and the execution is a perfunctory affair. The idea becomes a machine that makes the art. This kind of art is not theoretical or illustrative of theories; it is intuitive, it is involved with all types of mental processes and it is purposeless. . . . Conceptual art is made to engage the mind of the viewer rather than his eye or emotions.[2]

In practice, much of this work took the form of written or drawn statements, proposals and photographic documentation. Lawrence Weiner and Joseph Kosuth in America, or Daniel Buren, Yves Klein or Piero Manzoni in Europe established important bodies of work linked with this "conceptual art," drawing in elements of theory, confrontation and play. Such ideas led in turn directly to Performance and Body Art, as evidenced in works by Vito Acconci and Dennis Oppenheim in the United States or Amsterdam-based Marina Abramovic and Ulay, whose concerns were grounded in the idea but informed by physical limits and psychological parameters. Many artists working first with sculpture or painting moved to investigate more ephemeral and time-based issues through video or film at this period; others, younger, especially in Germany, Britain and North America, began at once with performance and media work. Shifting away from the marketplace and production of a "precious" object, the avant-garde sought to revalue intellectual engagement, to put process over product. Simultaneously, the role of the audience was redefined, to play a part in completion of the work through their response and feedback: the video model of simultaneous record and presentation, objectification and immediacy, was in effect reiterated.

With Canadian video of the early 1970s, especially in Toronto and Halifax, the *idea* generated and informed the work, and remained its most important aspect, very much in keeping with Lewitt's definition of Conceptual Art. The artist's intention (i.e., the idea) was central, so the video monitor tended to function as a mere channel for conveying the image/experience. In that situation artists virtually never prepared a script, or used a

set or crew; most often, the artist him/herself was responsible for every aspect of the piece, even to the point of being the single figure on-screen. Editing was seldom considered for these black-and-white recordings on half-inch open reels. It was generally assumed that videotape had a likely physical life of less than a decade. Permanence, then, seemed inadmissable; video was as ephemeral — and emphatic — as speech, its temporary capturing on monitor or tape, a mere wisp of memory.

Video had no obvious public, certainly no purchaser. In those first years, the fact that video was "not television" was crucial for artists; TV invariably suggested the gross commercialism, the predictability of subject matter, format and faces, that were intellectual anathema at the time. Video was taken up by individuals for what-could-be-discovered, what-could-be-experienced. It found its audience in other like-minded individuals rather than any "general public" — often other artists and usually the young and intellectually inclined. For many, it was simply "boring."

Fill (1970) by David Askevold, and Colin Campbell's *Sackville, I'm Yours* and *True/False* (both 1972), or such process/demonstrations as *Insertion (My Mouth)* by Eric Cameron (1973) are all quintessential for the moment.

As Askevold has described his 12-minute black-and-white piece,

> FILL is my earliest video work; besides the obvious filling of the screen with sheets of aluminum foil over a microphone on a stand, connoting an additive formal sculpture reading, the title also refers to filling time or a 'filler' on T.V. shows. The audio implodes during the wrapping of the foil and is more time consuming than the unwrapping, during which, the audio explodes as the sheets are pulled away from the microphone.[3]

The stationary camera was fixed to a tripod, its view centred on a microphone being covered, then revealed. As Lewitt had noted, the planning was done beforehand, the process intuitive and purposeless. An experiment.

In a similar manner, Colin Campbell's *True/False* is recorded in a single 15-minute take. We first see the artist's head in profile, as he makes a series of sixteen statements:

I like Sackville. True. False.
I have false teeth. True. False.
I have smoked grass. True. False.
I still masturbate. True. False.
I am part Jewish. True. False.
I am seeing a psychiatrist. True. False.
I have had crabs. True. False.
I snort coke. True. False.
I collect pornography. True. False.
I recently attempted suicide. True. False.
I am heterosexual. True. False.
I am part Indian. True. False.
I want to be a star. True. False.
I have committed bestiality. True. False.
I'm an exhibitionist. True. False.
Colin is my real name. True. False.[4]

Then he turns to face us directly, and repeats the same list. This time, however, he establishes eye contact with the camera lens, and thus apparently, strikingly, with the viewer. The tone of the statements is matter-of-fact, as are the affirmations and denials, but the information itself seems potentially volatile; the statements — either true or false — could readily be understood as confession or self-portrait. Campbell is performing his lines, yet the starkness of his presentation as he faces the camera alone, and the nature of the information itself, leads the viewer to a position approaching that of voyeur — or confidant. What are the viewer's motives or responses, after all? The ambiguity of that position is to be evoked often in the years to follow.

For the 30-minute duration of Eric Cameron's *Insertion,* the camera lens is rhythmically and repeatedly engulfed by Cameron's mouth, with attendant sync sound recorded in-camera. The viewer, identified with the camera lens, takes a "personal" part in this violation, being in effect swallowed in turn as he becomes implicated in the artist's testing of will or endurance, his intellectual curiosity — or possibly, his desire. The tape functions as a sculpture in time, the enactment and repetition of a single idea, playing on oral satisfaction and the penile presence of the searching lens. It is a sexual metaphor without erotic connotation, yet with every application of viewer/voyeur and applied/implied guilt.

EARLY NARRATIVE WORKS

Narrative works grew from Conceptual concerns, where the script became acknowledged as central to the work's construction. These narrative works included performance-based pieces as different as Vincent Trasov's *My Five Years in a Nutshell* (1975) as Mr. Peanut, and General Idea's *Pilot* (1977) — projects having little in common with Eric Cameron's earlier performative gesture of 1973. *Pilot* was commissioned by TVOntario, the local educational network, and General Idea presented their programme tongue-in-cheek as "pilot" for a long-running TV series (never intended by anyone to materialize).

> This is the story of General Idea, and the story of what we wanted. We wanted to be famous; we wanted to be glamourous [sic]; we wanted to be rich. . . .
>
> General Idea is basically this: a framing device within which we inhabit the role of the artist as we see the living legend. We can be expected to do what is expected within these bounds.[5]

Pilot used a full inventory of recognizable and appropriate TV tricks, with General Idea playing on-screen hosts themselves — or anchormen — to a panoramic collection of slides, photos, film clips, interviews, voice-over text and glib background music. General Idea used this air time opportunity to quote their own earlier work, but more importantly they were quoting the formal and conceptual vocabulary of television itself, their understanding sophisticated and tone polished. It might be noted that TVO was delighted with *Pilot*, and programmed it regularly for some months.

John Watt's *Two-Way Mirror* of 1980 is a further example of the central positioning of narrative construction, and another reminder that the formats and audience of the commercial media had begun to intrigue certain artists. This is not to assume, however, that these artists at this time wished to make "real" television, or to be a regular part of the commercial landscape, with its (automatic, necessary) attendant demands on both form and content, an ability to sell themselves or someone's products. These quasi-TV works are more playful and mischievous in their commentary/critique.

In *Two-Way Mirror*, a man sits in what appears to be his apartment living room, as he recounts without prompting or hesitation the sequence of events in his friends' complex lives . . . a seven-year history of *The Young and the Restless*, the popular daytime soap opera which had been his daily companion. A large mirror behind this speaker reflects portions of the apartment, or is taken over by scenes from the "soap," the two realities converging as thought bubbles or flashback memories. Watt had made the work for local cable broadcast in the "Television by Artists" series for which he was originator and producer (through A Space, Toronto, and the artist-generated Fine Arts Broadcast Service); the series was an important recognition of the new desirability, in artists' eyes, of an expanded audience and open context for video.

Vera Frenkel's work considered rather different aspects of popular culture and audience. By the late 1970s her performances and installation works were inquiring into the tradition of the "whodunit" in an extended series; a new group of works centred on the mysterious disappearance of (fictional?) expatriate Canadian novelist Cornelia Lumsden. For *Her Room in Paris*[6] (1979) Frenkel plays four stereotypical roles in turn as she appears as Lumsden's Friend, her Rival, the Expert on her life and work, and the CBC Commentator. With . . . *and now, The Truth (A Parenthesis)* the following year, the story took an unexpected turn as Frenkel is confronted on-screen by a young woman from the audience claiming to be Lumsden herself.

Frenkel relishes the storytelling mode with its twists of plot and character; her productions all play ironically with literary conventions and period phrasing and manners. But her work carries additional agendas enmeshed in the narrative: the artist as exemplary exile,[7] the intrusiveness of watchdog government ministries, the oddities and sly effectiveness of consumerism and capitalism-as-religion, the hardly registered persuaders everywhere in daily life. Stories are her form and the narrative is her means.

There is *another* narrative mode most unique at this juncture to the video medium, a narrative manner less text-based, less

concerned with broader consumer and culture-bound issues, and more reliant on visual intuition and a sense of interiority on the part of the artist. This form of narrative developed first in Toronto, perhaps most notably in the poetic language and intimate subject matter of works by Lisa Steele such as *Facing South* (1975) and *Waiting for Lancelot* (1977), or tapes by Colin Campbell after 1974 (including *The Woman from Malibu* series 1976-1978). Steele and Campbell were the first to define a new place for a visual and personal (intimate) narrative material — usually with open and nonlinear, inconclusive storylines — that suffused the whole field, though their influence did not lead to actual imitation by others. Somewhat related is *Delicate Issue* (1979) by Kate Craig, where the artist's camera roamed over her own nude body in extreme close-up, while her quiet voice-over muses,

> The closer the subject the clearer the intent.
> The closer the image the clearer the idea.
> Or does intimacy breed obscurity?

In this work she combines the consciousness of a media context as seen in Watt or Frenkel — a thoughtful interaction of individual and media references — with the intimacy and private revelation of Steele. In the larger picture of Canadian video history, these narrative pieces have offered unusually individualized works, the most singular voices and specific characterizations; it is the moment most uniquely ours.

Developing Dramatic Forms

Drama evolved naturally from these experiments with narrative, grafted onto a further valuation of television modes. In this way the first-identified "dramatic" works may be seen to have evolved out of such text-based pieces as General Idea's *Pilot* or, more closely, through Frenkel's unusual enactments. Theatrical or cinematic traditions at this time become more consciously utilized or applied, and scripts have more elaborated plots and traditionally developed story lines. *Crime Time Comix Presents Steel and Flesh* (1980) by Eric Metcalfe and Dana Atchley is an early quirky example of the developing dramatic mode, as are Noel Harding's ironic *Out of Control* (1981), or *Hygiene* (1985) by

Jorge Lozano and Andrew James Paterson. Colin Campbell, perhaps in preparation for his move to film production, expanded his concerns with scripting, cast and dialogue in *No Voice Over* (1986) and his hour-long *Black and Light* (1987).

Dialogue and a development of actors' roles and plot are the most characteristic elements of this phase, further elaborated with pointed quotation of film genres and themes. Metcalfe, for example, comments that

> "Steel" combines the format of the comic strip and the likeness of a "B" movie from the 50's, but discards the narrative and adopts the TV commercial's fast editing technique — packing it full of visual information of well known classic images that can be understood universally. . . . Film references are to early Kenneth Anger films and the staircase sequence is almost a direct quote from Alfred Hitchcock's "Psycho."[8]

Similarly, Noel Harding's tape is described as "A fast-paced, hard-boiled tale of sex, power and intrigue in high places, as inspired by G. Gordon Liddy,"[9] and in the Lozano/Paterson work "*Hygiene* is visualized in terms of both prime-time soap operas and the Sirkian/Fassbinderian melodrama. But the melodramatic formula is deconstructed by the juxtaposition of the heroine and provocative external information."[10] Though this fascination with film history and elaborated stereotypes flourished over several years, the central position given to the visual quote and knowing reference gives a family resemblance to the genre, and a certain clever superficiality. When the individual works were first released, the complexity of the plots, the highly developed dialogue, combined with the directors' new attention to mise-en-scène, seemed to bring together several loose threads developing in the fabric as a whole, and these works were met with pleasure and general congratulation. The results however are often overly self-conscious, a search for something new that remained incomplete.

A SOCIAL CONSCIENCE

By the end of the 1980s performance, narrative and dramatic genres had prepared the way for that "something," a new concern for social imperatives and public conscience, a political awareness that spread into many levels and areas of the arts generally.

The issues to be addressed varied widely. As early as 1984 Robert Morin and Lorraine Dufour (Montreal) filmed *Tristesse modèle reduit* (a dramatization of growth towards independence for a mentally handicapped young man), and in 1986 Norman Cohn completed *Quartet for Deafblind*; both were impressive feature-length works that had developed out of an ambitious rethinking of their makers' ongoing concerns and artistic means. In Vancouver, Lorna Boschman made *Scars* (1987) about self-mutilation and *Doing Time* (1990), a study of women in prison. Also on the west coast, Sara Diamond completed *Ten Dollars or Nothing* (1989) with voice-over interviews, archival footage and photographs, to discuss the lives of native women in coastal fish canneries of the 1930s. Diamond's *The Lull before the Storm* (1990) explores the histories of working class women and the changing definitions of femininity since World War II. Political issues, obviously, are central to all these works.

But these investigations of social change are not necesssarily presented as dogmatic, distanced or objective "truth." In a notable departure from his earlier work, Paul Wong's *Ordinary Shadows, Chinese Shade* (1987) is a study of his own cultural and family origins, recorded on location in China, as is Richard Fung's *The Way to My Father's Village* (1988), while Fung's *Chinese Characters* (1986) examines the ambiguous relationship between gay Asian men and white gay porn. Michael Balser, Andy Fabo and John Greyson (all Toronto-based) have made several works around the spread of AIDS and its effects, or, more generally, about sexual identity and attributes of individuals in a larger community.

The tapes include every variety of form and content, and continue to grow in ambition and scale. In 1991 Zacharias Kunuk of Igloolik completed the hour-long *Nunaqpa (Going In-*

land), second in a series recreating traditional Inuit life in the eastern Arctic over the cycle of a full year. The same year Lisa Steele and Kim Tomczak premiered their feature-length *Legal Memory*, a dramatization of events leading to the last death by hanging to be carried out in British Columbia (1959), capping an era of concerted persecution of homosexuals in the Canadian navy of which this story formed a part.

To a significant extent, these are elaborate fictions based in fact. They mark an important coming-of-age for many longtime workers with video. The issues are big ones: sexuality, race, the law, the family. The tapes continue to reveal two constants characteristic of Canadian video production: the presence of people, and the importance of verbal exchange. The "aesthetic" is a category whose significance is often downplayed in favour of social issues in the productions of the 1980s and 1990s, though as always the finest works retain allegiance to form, flow, content, beauty.

A DIFFERENT ORDER FOR QUEBEC

In comparison with the moments signalled in the foregoing for the rest of Canada, the development of video in Quebec is radically different, with the use of the French language by no means the only distinguishing feature. Concerns in Quebec focussed in broad terms on conceptual, narrative, dramatic and social issues, but not at the same time as elsewhere in the country, and often not for the same ends. In the early 1970s, for example, where an artist's approach to video in Canadian centres such as Vancouver, Toronto or Halifax was based on a sense of him/herself as an *individual* for whom the main interests were a development of visual and narrative imagery, or theoretical and performance-based work, the aim of video in Quebec was quite different. At that time in Montreal and Quebec City video was seen principally as a means *to investigate cultural issues* and *analyze national (i.e., Québécois) identity*, to the extent that video juries at the Canada Council, which typically included artists from both official language groups and from across the whole country, invariably came to a temporary impasse — a confrontation over the very

definition of art's meaning and purpose — before any consensus over awarding grants was possible.

Access to video in Quebec emerged first through the Groupe de recherche sociale and and the National Film Board's Challenge for Change/Société Nouvelle programmes; after 1971, Vidéographe in Montreal, more open to invention and change, became the major centre for production, exhibition and distribution. Use of the new medium coincided closely with the October Crisis of 1970 and Quebec's articulation of desire for independence; into the mid-1980s a socially conscious agenda has been paramount in Québécois video.

Especially noted works from Montreal include *Qu'est-ce qu'on a fait au bon Dieu* (1971) by Yves Chaput, a documentary on the official inquiry into the War Measures Act, and its querying of "the so-called October Crisis." Pierre Falardeau's *Continuons le combat* (1971) shows the world of professional wrestling as considered from an anthropological and semiological point of view, to analyze Quebec social rituals. *Le temps d'une prière* (1972) by Jacques Benoît and Jean-Claude Germain presents a critical study of the Catholic church and its place in Quebec families and education. In 1978 Pierre Falardeau and Julien Poulin completed their 90-minute *Pea Soup*, five years in production: a study of what they saw as national oppression, a dying culture complacently accepted in Quebec, "cultural hegemony at work." In 1979 Jean-Pierre Boyer's hour-long *Mémoire d'octobre* was a militant re-reading of the events surrounding and following the invocation of the War Measures Act in 1970, and preparatory no doubt to the referendum in 1980 for Quebec independence. Produced by the Comité d'information des prisonniers politiques, it was intended as a "tool for analysis and struggle in the process of transformation for Quebec society."

Not all early video in Quebec, however, was based in cultural politics so allied with national identity. Frank Vitale's *Hitch-Hiking* (1972, 42 minutes) is recognized as one of the most important early works in Canada, the result of a trip across the American border with a Portapak under his arm; his use of video as unobtrusive eye and ear, his secret recording of conversations

with others, including highway patrol and customs officials, mark it as a classic in the "underground" film tradition of the 1960s.

More characteristic of independent work from the 1970s in Quebec, however, are such "socially concerned" works as *L'amiantose tue* (1973) by Claude Bélanger and others, an indictment of health and safety practices at such mines as Atlas Asbestos. At the end of the decade come landmarks such as *Chaperons rouges* (1979) by Hélène Bourgault and Helen Doyle, a dramatization of violence against women, and Norman Thibault's *Joe* (1982), a docudrama on alcoholism in the workplace.

But as might also be expected, other threads have appeared. The seldom-seen *Réaction 26* (1971) by Charles Binamé was an early black-and-white experiment with electronic feedback, in touch with other technical researches into editing and sound recording being done at Vidéographe. Jean-Pierre Boyer's more characteristic early works — researches with computer, feedback and manipulation of the screen raster — also date to the early 1970s and relate to his teaching in Toronto at the Ontario College of Art and in Buffalo at SUNY Buffalo where he was working with Steina and Woody Vasulka. Boyer remained virtually unique in Canada with his studies in such medium-specific areas. Further interests by others in image manipulation were to surface only much later, in such experiments as *Distance* (1984) by Luc Bourdon and François Girard, a study in slow-motion movement, or Girard's *Tango Tango* (1988), a dance work recorded in elegant black and white, with numerous postproduction effects. A new cross-fertilization developed in the mid-1980s: visually eloquent dramas with social implications — a compendium of all four of our categories — in such works as *Le train* (1985), also by Girard, which is an allegory of memory and imagination, where "the life of a railwayman has come to a halt at just the same place as his locomotive," or the langorous *Réminiscences carnivores* (1989) by Marc Paradis, a poetic evocation of sexual pleasures and personal memories.

At this point the categories collapse in Quebec. By the later 1980s both form and content for video productions seem to have

coalesced around production groups in Quebec (Vidéo Femmes) and Montreal (Vidéographe, PRIM, Coop Vidéo, Groupe Intervention Vidéo, Agent Orange), each with access to different equipment, and each with their own "look" and agenda. To a notable extent, each group seems to deal cautiously with the others. There is a lot of new work, with the medium enjoying a notable resurgence, but generalizations are applicable only to individual careers, and no longer relate to a community identity. Indeed, with widely varying aspirations for audience and production values, new video coming out of Quebec may be considered a whole only insofar as French forms a common language base, though even there several artists have moved away from dialogue of any sort, preferring the versatility — portability — of images-on-their-own.

Quebec video was early marked by social conscience and a desire to investigate national identity; later it turned to narrative concerns and a striking mix of dramatic imagery with social conscience. The continuing development of these combinations is producing a new moment, unknown elsewhere and still volatile in Quebec.

<p style="text-align:center">* * *</p>

Over a quarter-century of small-format video production by artists and independents in Canada, the four moments — conceptual, narrative, dramatic and social concerns — have generated unique works in the medium, a vocabulary unlike others'. The terrain is rich and varied.

NOTES

This essay was written in 1992 and first published in Janine Marchessault, ed., *Mirror Machine: Video and Identity* (Toronto: YYZ Books; Montreal: CRCCII [Centre for Research on Canadian Cultural Industries and Institutions], McGill University, 1995). It was revised for publication in this volume.

1 Previously published histories include my own early essays, "A New Medium," in *Videoscape* (Toronto: Art Gallery of Ontario, 1974), and "Video Art in Canada: Four Worlds," *Studio International* 191, 981 (May/June 1976): 224-29. See also Andrée Duchaine, "Historique de la vidéo au Québec," and Renée Baert, "Video in Canada: A Context of Production,"

both in *OKanada* (Berlin: Akademie der Künste, 1982); and Renée Baert, "Video in Canada: In Search of Authority," in René Payant, ed., *Vidéo* (Montreal: Artextes, 1986). See also Sara Diamond, "Daring Documents: The Practical Aesthetics of Early Vancouver Video," in Stan Douglas, ed., *Vancouver Anthology: The Institutional Politics of Art* (Vancouver: Talonbooks, 1991). For much of this activity, artist-run production/exhibition facilities, usually with government support, have provided an important backdrop. Major related events are listed and discussed in A. A. Bronson, ed., *From Sea to Shining Sea* (Toronto: The Power Plant, 1987).

2 Sol Lewitt, "Paragraphs on Conceptual Art," *Artforum* 5 (Summer 1967): 80-81.

3 *Art Metropole Video Archive Catalogue 1991* (Toronto, 1991), p. 4.

4 All quotations from artists' tapes are transcribed by myself from the video, unless otherwise noted. *True/False* is illustrated on p. 34, with Campbell on screen.

5 General Idea's statements reappear in numerous works and publications, as noted in their retrospective catalogue (*General Idea, 1968-1984*, ed. General Idea and Jan Debbaut [Eindhoven: Stedelijk van Abbemuseum, 1984]).

6 *Her Room in Paris* (1979, 60 min.) exists as a single-channel videotape but also as one element in the larger installation work of the same year, where the tape plays on a TV set sitting on Lumsden's partially painted bureau, and surrounded by evidence of interrupted habitation (illustrated on p. 106).

7 A text-and-photos work including references to several of these themes, mixed with elements from Frenkel's videotape *Stories from the Front (& Back): A True Blue Romance* (1981, 60 min.) appears in Vera Frenkel, "Stranger in a Strange Land," *Impressions* 28/29 (Winter 1982): 13-19.

8 Eric Metcalfe, *Catalogue, Western Front Video* (Vancouver: The Western Front, n.d.) (illustrated on p. 34).

9 *Art Metropole Video Archive Catalogue 1991*, p. 20.

10 *The 1991 Catalogue of Catalogues* (Toronto: V/Tape, 1991), p. 40.

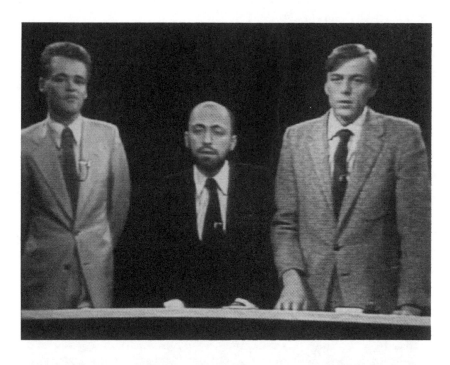

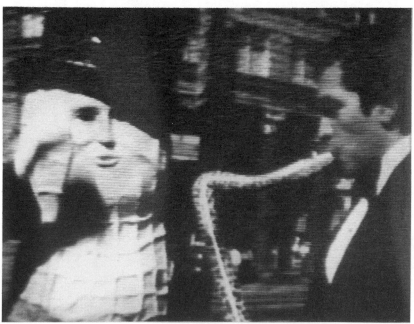

2

WHEN VIDEO FIRST
CAPTURED OUR
IMAGINATION

A rtists' video is hardly a form of commercial television, but
there is no doubt that the TV screen, a familiar icon in
every home, proposes by its simple appearance a relationship be-
tween the two. The interplay between video and TV — commen-
tary, emulation, critique — has vacillated widely over the quarter
century of artists' use of the medium; new reliance on computers
for so many offices, homes, industries, makes the monitor even
more ubiquitous. But the cathode ray tube is still no simple "de-
livery" system. Television remains an issue and unspoken chal-
lenge to any North American environment for culture.

SOME RECENT FIGURES FOR TV AND "ENTERTAINMENT"

Virtually every household in Canada has a television set, with
colour TV now the accepted norm. Statistics Canada, indeed,
points out that by 1993 fully 46.1 percent of Canadian households
had two or more colour sets — up from 32.6 percent five years
previously and just 15.7 percent 10 years before. No longer luxury

Opposite page above: A. A. Bronson, Jorge Zontal, and Felix Partz in *Pi-
lot*, 1977, by General Idea. Photo courtesy of VTape, Toronto.
Opposite page below: Mr. Peanut (Vincent Trasov) and Dr. Brute (Eric
Metcalfe) in *My Five Years in a Nutshell,* 1975, by Vincent Trasov. Photo
courtesy of Art Metropole, Toronto.

items, videocassette recorders have become standard fixtures in the home; in 1993, 77.3 percent of Canadian households had a VCR, compared with 6.4 percent a decade earlier. In fact, in 1993, 12.9 percent of these households had more than one VCR, up from 9 percent in just one year. Statscan goes further to note the "cocooning" trend in Canadian households, where the ownership of media-related leisure items is growing notably — with such examples as home computers (23.3% in 1993, 10.4% in 1986) or camcorders (12.4% in 1993, 10.2% a year previously) and satellite dishes (2.7% in Canada in 1993, the first year data was collected, and 6.4% in the province of Saskatchewan). At the same time, outdoor recreation goods like snowmobiles (6.3%), boats (14.8%) and overnight camping equipment (28.6%) have shown little growth in popularity since the early 1980s. Even adult-size bikes (owned by about half of Canadian households) and skis (owned by about a quarter) have been nearly static for a decade.

Since 1980, average viewing time for television has remained comparatively stable — between 23 and 24 hours per week — despite significant increases in the number and variety of viewing options during the period, (including tremendous growth of cable and Pay-TV). Yet the hours-per-week has nevertheless been in a slow but steady decline since mid-decade, reaching 23.3 hours by 1991 (the most recent figures available from Statistics Canada, published April 1993). Of Canadian households, 68 percent had cable in 1987, compared to 47 percent in 1977. Thirteen percent of households subscribed to Pay-TV, which was not even available a decade earlier.

Figures comparing at-home viewing with movie-theatre attendance are just as revealing. In Statistics Canada's report on the film industry in Canada for 1984 (published May 1987), we find:

> For the second time since its introduction in 1953, television is posing a serious threat to attendance at motion picture theatres. Attendance at regular and drive-in theatres reached its peak at 256 million admissions in 1952. The next year saw the introduction of television in Canada and theatre attendance began a slide that lasted for ten years, levelling off at about 100 million admissions in 1963. The introduction of colour television in September, 1966 had no effect on theatre attend-

ance. Statistics Canada data for 1983 and 1984, however, show that this 20-year period of mutual compatibility is over.

Television's second attack on theatre attendance has come through the VCR. Between 1982 and 1984 theatrical attendance dropped 18% to under 80 million, while VCR penetration of households at 6% in 1983 doubled to 13% in just one year.

A *Globe and Mail* report of 9 January 1993 quotes newer figures:

> The living room has overtaken the neighborhood cinema as the venue of choice for Canadian movie-watchers, newly released figures suggest. Families spent an average of $75 on videocassette rentals in 1990 compared with $72 on movie tickets, Statistics Canada reported yesterday.
>
> Paid admissions to theatres and drive-ins dropped in the 1990-91 fiscal year by almost 4 per cent from the previous year, continuing a trend that persisted through the 1980s. . . . meantime, the dollar value of video rentals has shown average annual growth of 16 per cent since 1986.

Statistics Canada pointed out that home entertainment distribution (including conventional television, Pay-TV, cable and home video) accounted for 70 percent of all distribution revenues in 1990-91, up from 61 percent just the year before — a figure which had been maintained for several years.

Projections of a "wired world," construed as fantasy in the relatively recent past, are certainly confirmed as fact. There are new assumptions about the *entertainment* value of television news, about accessibility to information and advertising, the influence of TV on family life and values and the nature and quantity of desirable "entertainment." News anchors on major networks are offered the fabulous salaries of sports celebrities (and are wooed for their "believability" and on-camera appeal); fictional dramatizations may be part of formal news reports; hidden microphones collect surprise admissions. Any number of traditions are open to question in current television, where simple "reporting" continues to recede as an option. What will *sell* best?

The "average Canadian" watches over three hours and twenty minutes of television every day: watching a box in a room, where out of every hour there are up to 12 minutes of commercial messages, where one's attention span is reduced to minutes for the

programmes and seconds for the sponsors — and where sponsors put more care and usually more money into their commercials than is virtually ever available for the programmes themselves.

EARLY REACTIONS

Richard Serra in 1973 made a videotape called *Television Delivers People* (6 minutes, colour), a rolling script with Muzak accompaniment:

> You are the product of t.v.
> You are delivered to the advertiser who is the customer.
> What television teaches through commercialism is
> materialistic consumption.
> Popular entertainment is basically propaganda for
> the status quo.
> Control over broadcasting is an exercise in controlling society.
> You are the product of television.
> Television delivers people.

Nam June Paik, video pioneer, proposed that we talk back to our television sets, make our own programmes. "Guerilla television" and "radical software" (as ideas, and also as the name of a video production group and of a publication, respectively) were touchstones for video, especially in the United States in the late 1960s and early 1970s. Andy Warhol (1930-87) understood the television environment perfectly, and admired its homogenizing tendency; as he suggested, "In the future everybody will be world famous for 15 minutes." At the same time, there was a movement in favour of *changing* the nature of the medium itself, making it a two-way information exchange (on the send-receive model of the telephone rather than the single-point broadcast model of radio) — instead of what was perceived as an in-home marketing terminal for standardized products and ideologies. With the arrival of the Portapak a democratization of TV hardware was possible, and it proliferated quickly. Everyone can do it (just another fad). Those riding the wave of the fad soon abandoned it for the next one to come along, and those others committed to guerilla television or alternate media replaced the too-present, too-amateur, too-rambling video with tighter politiciza-

tion and professionalism by resorting to other (often more tradi-
tional) means of expression. A first stage for independent video
came to an end about 1980.

HOW TO LOOK AT VIDEO: 1970S

In those early years, it was common to hear how BORING video
was, even from those who were using the newly available me-
dium as a means of artistic expression. True, video is not like
broadcast television programming with its four 30-second com-
mercials, 12 minutes of programme, one-minute break, another
couple of 10-second spots, 12 more minutes of programme, and
four 30-second messages. But why was video called boring?

Video didn't follow the patterns or assumptions of commer-
cial television — unless, possibly, there was a specific point to be
made or — rare occurrence — the piece was being pitched at TV
as possible purchaser. Tapes seldom fit into approximately 30- or
60-minute packages simply to comply with commercial custom.

At first, few videotapes were edited, in part because the
equipment available was so primitive. They were presented as
recorded with whatever editing done in-camera during shooting,
and might be of any length at all. Documentation of a perform-
ance piece could take hours, or a couple of minutes; either way,
the resultant videotape had little in common with "entertain-
ment" fare. The tape did not necessarily tell a story, nor have a
succinct and obvious message. The overt content of the piece
might well be difficult: Colin Campbell saying, over and over,
"This is the way I really am" (1973, 20 minutes) as he positions
sections of his body, the left half shaved and oiled, before the
camera, or Vito Acconci trying to force open the eyes of a resist-
ing woman (*Pryings*, 1971, 20 minutes) or again, in *Waterways:
4 Saliva Studies* (1971, 20 minutes) where Acconci "tests the
boundaries of his mouth as a container for saliva . . . he is using
a bodily process for its visual and dynamic properties."[1] These
tapes were not intended to be narcissistic, cruel or disgusting,
but to identify and deal with character and personal data. Body
Art, closely allied with video, saw the "I" of the artist as ground

for experimentation. The tapes confronted facts or situations played out in public, in analogy with sculpture and theatre.

"Boredom" is the wrong word. Boredom results from not finding a response to match expectations or desires. Perhaps the sense of strain associated with watching videotape has more to do with literal physical and emotional fatigue than with boredom. Perhaps watching video can be literally "tiresome." Certainly the eyes may easily strain at too-close attention to a television screen; at home with the TV there are plenty of diversions, but video in a public forum tends more often to demand concentration. When video was recorded in real-time — that is, unedited — the viewer might well become tense or restless, especially when it seemed necessary to see the tape through to its conclusion. Without the structure of a story, pacing oneself was impossible. The viewer's attention was a necessary constant.

"Video is such hard work," some would say. "Video is so BORING," others replied.

However, confronting one's intellectual, emotional, social responses through a work of art is not "boring." Seeing this process happen in another person, through the immediacy of real-time video, can be challenging.

Unedited video offers raw information. It includes mistakes or chance occurrences, and to watch it takes as long as the time required to perform it. There is a quality of focus that seems unique to video, both in front of the camera and in front of the monitor. This has partly to do with the screen's ability to frame vision or action, and also with a common human scale in the recorded images. Television loves the close-up and the talking head. Watching that glowing box, one feels alone in the room; watching light define form, the eyes are in constant motion. As mind and eyes decipher and complete the images, the whole body is attentive.

For the person in front of the camera, there is the knowledge that the camera is recording everything it sees, instantaneously. With no need for processing (as with film stock) there's no split between present and past — a performer can see him/herself on the monitor as if in a reversed mirror, knowing that in seeing-

the-image-on-screen, that "present" moment is already part of history. Time collapses visibly, the present slipping between acknowledged past and implied future. This was particularly true of the early performance works, where ongoing action was so often influenced or changed by the reiteration of the monitor. Lisa Steele, for example, continues to reposition herself for the camera in *Juggling* (1972, 6 minutes), and in *Lisa with the Egg* (1972, 10 minutes) she uses the monitor as a mirror to apply clown makeup before deciding to pop the whole egg into her mouth. Editing decisions happened during the making of the work (in response to the camera's view) rather than afterwards. "Feedback" became part of everyday language.

Complaints of another kind of "boredom" were made. "Video is so SELF-CENTRED, so self-indulgent." Rosalind Krauss, for example, saw narcissism as video's central characteristic, and her discussion of the medium in these terms[2] was the most articulate of many similar statements. Certainly video was an ideal means of self-study: impartial, laconic, specific, it seemed to elicit secrets. In those early days the whole process was often done alone — camera operator, actor, editor and audience being the same person. Using natural light in the corner of an ordinary apartment, the temptation to "tell all" was, for some, irresistible. The 1970s seemed a time specializing in personal charade and self-questioning and the boldest of themes were played out in this simultaneously most intimate and public of media. Drawing, painting and literature have been open diaries for many artists, consciously or otherwise, but in the video of the 1970s the information tended to be explicit. Lisa Steele, in *A Very Personal Story* (1974, 17 minutes), detailed her mother's death a decade previously; Rodney Werden, in *I'm Sorry* (1974-75, 11 minutes), strips off his clothes to be caned; Al Razutis, in *Synapse* (1976, 26 minutes), carries out a biofeedback experiment; Colin Campbell, in *Secrets* (1974, 20 minutes), talks about an intimate relationship. Such interest in (or need for) exposure was emblematic for the medium in those years.

By the end of the 1970s, video-time had largely changed in favour of editing and postproduction; the information was no

longer "raw." Entirely new issues jostled for attention. With more conscious internal structuring in the tapes, they became easier to watch and less relentless in their demand for attention.

PHYSICALITY AND FEEDBACK

Video exists only during the time in which it is being experienced (played back through closed-circuit or broadcast systems). Even as a tape is played, the video image may assume a variety of sizes and intensities of light, depending on the monitor or TV set used for playback. Whereas film remains a series of visible images on celluloid (even in storage), videotape appears as an undifferentiated opaque gray ribbon with one shiny side, its message decoded only electronically. In this sense, video images have no tangibility. Yet response to the video image can have a surprisingly physical quality. We see video emanating as a source of light; it is "here," projecting from within, as would a person standing before us. Its presence demands attention. Television is referred to as "the eye" or "the tube" — in one case it is anthropomorphic, in the other, an impersonal conduit. Both show the easy dismissal of familiarity — as with another member of the family.

The viewer is distanced, though not disengaged. Distanced, because the cool phosphorescence of the cathode ray tube will not stabilize for position in eye or mind. Experience and response are ongoing; genuine relaxation isn't quite possible. The "presence" of video is engaging, but at arm's length; the viewer is constant subject to the object represented by the work. The two presences (viewer and viewed) are isolated yet entangled in a curiously responsive one-way confrontation. While the taped work is not actually open to change, it does invite reflection in the viewer; through the "eye," information loops back to propose change to/in the viewer. A sharing of response is offered through such feedback.

Video is not properly a communication tool. Its function does not correspond merely to manual operation, as with the direct extension of the hand working a pencil, or paintbrush or playing a keyboard. Like language, it has its own demands and input,

and colours any activity with its own processes. Not simply a tool, it translates the desires of its operator into its own terms. Thus ideas and emotions put into the world on videotape have a complexity that is not at once apparent. A viewer responds to the visual and aural stimulation of the taped message, while being "plugged into" the dominant information-source for our culture. The video monitor is also the TV set which brings us the evening news and 12 minutes per hour of commercials; while early users of video might claim the virtue of raw information and real-time as "truth," the presence of commercial television was never forgotten — though TV itself was hardly considered "pure" entertainment. With advertising now found at movie theatres, sportscar races and even the Olympic Games, perhaps no diversion is "pure."

Herein lies the double impact of colour, introduced to artists' video in the 1970s. Then still new and expensive, colour television had a glamour quite separate from the evident appeal of red, blue and green. An immediate reference to consumerism and success, colour video was sought out as an open response to the challenge of money and the marketplace. General Idea's *Pilot* (1977, 28:50 minutes) and Ant Farm's *Media Burn* (1975, 25 minutes) were two of the most compelling examples of artists' acknowledgement of the mainstream media and commercial appeal. In both tapes, the artists foregrounded broadcast traditions to juxtapose content and context in admiring, if ironic, recognition of commercial television's importance. Ant Farm created a dramatic "media event" and invited the media to cover it in regular news items. They then incorporated this commercial coverage into their performance framework, where the Phantom Dream Car crashes through a pile of 50 flaming television sets at San Francisco's Cow Palace. General Idea, on the other hand, created their *Pilot* as a work commissioned for broadcast to outline their programme of construction for the *1984 Miss General Idea Pavillion*, and "sell" General Idea itself. Playing on the concept of "real" television, they transcribed model into archetype: an anthropology of contemporary idioms.

Television is one of history's great success stories, and our lives have indeed been affected by its development. At first, artists wanted to "get back" at television by denying or subverting its assumptions. With the passing of two subsequent decades, video standards and techniques have fully infiltrated film — and vice versa, to a significant extent. Border defences are falling, and that border itself may be discontinued. New patterns of free-time use and different means of information access and retrieval are abundantly evident; by way of the word processor and computer screen, the cathode ray tube has assumed a central place in the management of everyone's daily business. Computer literacy is considered essential even in the earliest grades of the public school system.

Indeed, it has been proposed that the personal computer has already replaced traditional television. Derrick de Kerckhove notes that TV didn't develop its real niche of influence until

> post-war society in the "free world" had been accelerated by the wartime industrial production and the consequent need to float the growth of domestic production. TV changed the world faster and better than both world wars. . . . TV created the first and only real "mass" culture, beaming in from the screen a clone model of behaviour to a passive consumer. . . .
>
> [But] the action is not in the television aura anymore. TV culture was over in the late 1970s when computers began to erode mass indoctrination by providing opportunities to talk back to the screen. . . . [3]

His point is that interactive computer networks, telecomputers, camcorders and the like allow a new environment of information exchange and receipt-on-demand. These shifts may be seen to herald a world without television as we've come to define it, and without familiar advertising either, for consumption no longer gives society its "meaning." To a certain extent, early demands by artists and others — that television offer a two-way exchange rather than a one-way marketing terminal — have been fulfilled in unexpected ways.

Western society is flying into a present, perhaps, that replaces the previous (distant) horizon of the future. To look back

at artists' video of the early 1970s is to discover a world quite innocent by today's standards. It requires an effort of imagination now to find that past, to locate its vision . . . and to see its role in the development of tools, structures and assumptions now unfolding.

NOTES

This essay, revised and retitled in 1994, was originally published in *Parachute* 7 (Summer 1977) and *In Video* (Halifax: Dalhousie Art Gallery, 1977) under the title "Video Has Captured Our Imagination."

1 Lizzie Borden, catalogue description, *Castelli-Sonnabend Tapes and Films* 1, 1 (November 1974): 5.

2 Rosalind Krauss, "Video: The Aesthetics of Narcissism," *October* 1 (Spring 1976): 51ff.

3 Derrick de Kerckhove, "Private Networks in Public Mind," *Mediamatic* 7, 3/4 (Winter 1994): 251-53.

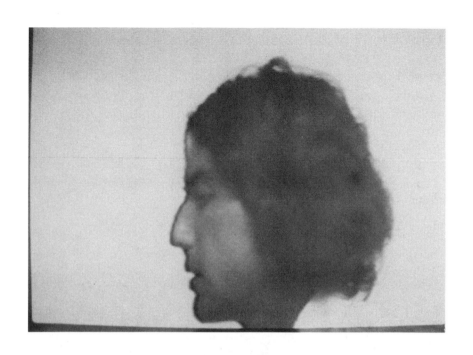

3

"TO TELL THE TRUTH . . ."

NARRATIVE AND FICTION IN ARTISTS' VIDEO

N arrative is an ancient art, a prime impetus for speech itself. We even dream in stories. As sequence and flow, actions seem to have consequence, with one-thing-after-another implying a relationship of cause and effect. This is a comforting idea, however illusory.

Narrative permits deduction, tracing elements from an "origin" towards an implied conclusion — or vice versa. Conjecture is built upon and elaborated from even the most incomplete evidence. When a beginning-middle-end arrangement is ruptured, reversed, incomplete or even entirely absent, the viewer, reader or listener can continue to follow along. An interest is all that's required. Ordering the world into narrative permits logical understanding, and reveals a desire for meaning.

Into the loose agglomerate of available material comes the *edit*, its deletions shaping and tightening results, whether the presentation is oral, written or visual. The confusion and disorder of experience are controlled, made (apparently) rational and relational. The narrative structure so produced also tends to shape viewers' understanding of what is being recounted, for it

Opposite page above: Still from *True/False,* 1972, by Colin Campbell. Photo courtesy of V Tape, Toronto.
Opposite page below: Still from *Steel and Flesh,* 1980, by Eric Metcalfe and Dana Atchley. Photo courtesy of Art Metropole, Toronto.

limits the nature and quantity of information available as it controls the form of presentation (camera movement, sound, etc.).[1]

Editing as a structuring device is the crucial feature of narrative; an unmediated reflection or translation of the living world is simply not possible in representation. In film or television, the "long take" may begin to suggest an experience of actual time, but work recorded in continuous "real" time is far from neutral, already a framed narrative, and for most viewers seems drawn out, even confusing. The more traditional means of manipulation in filmic storytelling — multiple viewpoints, close-ups and juxtapositions — all foreground the fictions inherent in *any* representation. No recording is "truth": selection, sequence, framing, editing shape all materials and, in so doing, affect the viewer's understanding or response. Thus "truth" is a construction, or more possibly, a "serious fiction."[2] Indeed, one might marvel today at John Grierson's early and innocent definition of the documentary as the ideal form for "observing and selecting from life itself," for "opening up the screen on the real world," for photographing "the living scene and the living story," where one may learn "without material interference, without intermediary."[3]

AND TELEVISION?

Television is composed of programme series and regular, standardized time slots, with "specials" as pre-emptive rarities and advertising spots as both structure and punctuation. Dramas, documentaries, game shows and news are the common fare. The quantity and, to a lesser extent, the variety of broadcast fare may be said to be increasing in response to the splintering and diversification of markets. With a "mass" audience no longer assumed, a variety of viewers must be courted. But most network shows repeat patterns established years ago.[4] In the daily or weekly instalments of an ongoing series, each segment is self-contained. There is no cumulative "learning" intended or possible, though individual characters establish personalities and predictable responses, and become familiar; viewers begin to feel comfortable with the characters and the events of their "lives," and to

care what happens to them. With time, these stories seem *life*like. Each segment of the series is virtually interchangeable, in that none requires knowledge of previous events in other programmes; a segment may take its place at almost any point in this linear (continuing, but not evolving) sequence. The sequence may be jumbled and truncated by the networks, or extended (and repeated) indefinitely. Characters in the core cast retain their original personality traits and, ever resourceful, respond to each development in turn.

The television viewer is solo, even when accompanied. Whether seated before the screen or watching intermittently from another room, the viewer is not at all "spellbound in darkness,"[5] but rather continues "watching" even while carrying on a conversation or reading the newspaper. Whereas the "big screen" of cinema demands the visible sweep and gloss of high production values, depth of field, lushness of colour and scale, these values are impossible for the little "eye" of television. Big-budget film can BUY verisimilitude; television is trashy by comparison. Thus television is considered less "realistic." Film is sensual, emotionally engaging, while TV tends more to a visual involvement, engendering a "state of aimless fantasy and daydreaming below the threshold of consciousness."[6] We all know that the presentation or enactment of these stories on film or TV (as with literature) requires the audience to forget the "fourth wall" bounding a given scene, permitting the image before us to become "real" (if not exactly believed) through identification. Space and time give way before the requirements of a story's "now," be it in past, present or future tense. All that we see and experience is, briefly, "true" for us.

In considering narrative, one might also consider *dreaming*: another kind of story with different rules and parameters, and a different kind of desiring "mediation." Sleep functions as "down" time for the body, while the mind continues to work; the language of dreams — condensation and displacement — is not unlike that of narrative's metaphor and metonymy. As with constructed narrative, secondary elements in the dream are deleted, events rearranged, and new angles of vision present different

facets of the material at hand. Dreams may prefigure or illuminate facts that are unnoticed while awake. Their events and personages are coincidental tools for learning.

Television programming, likewise, may influence inadvertently, through suggestion, analogy and simple repetition. Its most powerful lessons are unspoken,[7] and it is the implicit rather than explicit message that is most likely ingested. The speedy pacing and no-surprise formats of television are additional draws on viewer attention. Nothing "extra" distracts or takes time, as even transitional elements, apparently unnecessary to the main storyline, are included to maintain variety and viewer interest. The work is thus as compact and effective as possible.

Television, like film and literature, may offer a surrogate for direct personal experience, action or pleasure. It can provide a form of vicarious living, giving the viewer a feeling of actually having taken part in the events unfolding on screen: hence, harnessing a viewer's sense of potential power and effectiveness. In the dreamland of television, a happy ending is always possible, a witty rejoinder always available. TV offers visible order and control, a place of easy desire and promised fulfilment — as proposed literally (though ironically) in *Fait Divers: elle remplace son mari par une T.V.* (1982) by Lynda Craig and Jean-Pierre St-Louis, where a suburban housewife becomes so enmeshed in her favourite afternoon soap opera that she comes to believe it is all true, those characters and situations becoming more meaningful and "real" than her own husband and son.

OLD NARRATIVES FOR NEW

While narratives of the earliest types in Western civilization told of gods and heroes in poetry, drama and song — firmly anchoring history and social/moral codes for preliterate societies in the communal memory — the 19th century saw the novel develop as the most popular literary form; its influence has only begun to be overtaken by film and television in recent decades. Narrative fiction continues to propose social and personal values, models for action.

Narrative has moved easily and comfortably from literature to the moving image, and mystery stories, morality tales, com-

ing-of-age accounts, romances and so on, all continue to offer themselves as ready subject matter in the new (media) forms.

In artists' video, one of the "newest" of the new forms, scripted narrative had become important by the mid-1970s. Within the larger field, in turn, *autobiography* showed itself to be of central interest; perhaps the medium's simplicity of operation, especially in the early years, suggested the personal note-taking previously possible only with pen or pencil. The monitor was immediately third person and *outside* the live performer. The diarist or autobiographer reflects "truth" in detailing events and motives, perhaps seeking explanation for himself or herself as much as for an assumed audience. In autobiography's first-person preemption of biography, object (third person) becomes subject, aiming to control or influence both public knowledge and memory and often flirting with fiction in the process.

Colin Campbell's videotape *Black and Light* (1987, 53 minutes), for example, is presented as dramatic fiction, yet draws all its elements from the artist's private life. The tape (whose several actors are all friends with whom Campbell has worked previously) sketches out a couple's break-up and their attempts to explain their needs and desires, tensions and discontents, to themselves and each other. *Black and Light* moves deliberately, seeming realistic and natural in its characters' actions and responses to (common) personal crises.

This approach is a variant of Campbell's strategy over many years, where he has used events from his own life to inspire or support narrative structures in video format. At first the artist himself appeared on screen as central character or performer. In later work he tends to make cameo appearances only, or avoid the camera's eye altogether — yet the close linkage of the artist's life (events, but also friends, family, sexual anxieties, intellectual interests) with the people and events depicted in his many tapes, follows a clear line that is evident in an overall review of his work. As Bruce Ferguson has pointed out, Campbell's assumption of other (and multiple) identities "is a kind of marginal realism which can only be arrived at by a complex restructuring of an imaginary self, in much the same way that video art shadows

the twin discourses of art and television. In much the same way that male anxiety lies just below its projection of stability."[8]

Confession is autobiography's close relative, the video variety tending to stray notably towards fiction and romance. Those working with the confession form via video use the medium as a mirror for revelation — or perhaps self-justification and catharsis before an audience. The viewer, in turn, may experience a vicarious pleasure in this performance, often in direct relation to the intimacy or extremity of the revelations. Confession may sometimes be didactic in intent (emulate this/avoid this), but in video it seems more often related to theatrical performance — or on occasion, neurotic acting-out.

Campbell's earlier tapes are exemplary of the confessional mode, in both their simplicity of form and the specificity of content. *True/False* (1972), for example, is especially stripped-down. It is a performance where he was responsible for every aspect, technical as well as formal. There is no attempt to hide, no distance or camouflage. This is an "I" in direct address to an imagined viewer. One believes Campbell's words . . . and then believes his denials. His starkness of presentation, his direct gaze, are conventions of narrative truth; the power of the camera is underscored, even defined, in this early "performance" tape.

Fiction, autobiography, confession, are all stories that conform in varying degrees to the social concensus designated as reality. But "truth" as a component to the narrative may be entirely irrelevant, and "reality" itself may be a construct, almost a matter of opinion: fantasy, invention, memory, are all open to blurring and manipulation, whether or not intended.

FORMAL SHIFTS

Unconventional formal construction and extensive use of written or spoken elements, often presented voice-over, may thwart expectations and put the viewer on guard. That viewer is almost certainly familiar with commercial TV programming and movies, but is often impatient with artists' video or experimental film. The "good" (i.e., naturalistic) acting, lively pacing and slick production values of mainstream media offer a comfortable conven-

tion, even an academicism, enticing the viewer into easy suspension of disbelief. Yet the surprises of independent video works — uncommon subject matter, unexpected edits or slips of sequence, "real" people (amateurs) rather than actors — are customary to much independent work.

Twenty years ago, equipment available to artists was so primitive as to make editing nearly impossible. Often, video images were presented on monitors simultaneously with their recording; these performances emphasized both the image and its live source for viewer and for artist/performer. At that time "real-time" was seen as the ideal mode, the form most unique for the medium and, unlike what television seemed to embody, the mode with the fewest "tricks." The choice was a political one.

Campbell's *True/False* is one example of such a closed-circuit real-time production. Another work from this period is Lisa Steele's *Juggling* (1972, black-and-white, 6 minutes) in which a fixed camera presents the artist in medium close-up against a plain white wall. She is juggling three balls, not very expertly; as one or another of them falls she stoops to retrieve it, then continues, her glances off-screen indicating her consciousness of the recording camera. The action is oddly mysterious, and at first seems pointless. Then Steele stops, faces the camera directly, and says in a quiet, earnest voice, "When I get really good at juggling, I'm going to have 14 glass balls, filled with a gaseous liquid that's just slightly heavier than air, and it'll be sky blue, so that when I juggle them they'll be totally invisible." Then she walks away from our field of vision, ending the piece. This surprising statement "explains" her previous action, showing it in an entirely new light, colouring it with desire and fantasy through her projection of future skill at juggling. The very unlikelihood that this expertise will ever be developed or attempted, reveals Steele's otherwise austere "performance" as a personal one, executed simply for her own (and our) pleasure. But the performance also seems to comment with irony on then-current male performance art, such as well-known works by Chris Burden, Vito Acconci or Dennis Oppenheim, with their emphasis on endurance, danger and public confrontation.

While the "real-time" video of the 1970s was consciously and intentionally "not TV," it also tended to be "not art" in the terms of claims to value, uniqueness and permanence customary for galleries and museums or private collections. Certain artists chose to differentiate video further from "the box" by showing their work in multi-monitor installation form, with one or several channels played simultaneously on an arrangement of screens. Paul Wong's multi-channel studies of dancers or subway arrivals and departures are typical examples from that period. But options available to artists remained severely limited by lack of equipment and studio access.

To artists working with video in the 1990s, the forms and formats of television are no enemy to be confronted; television's codes and high gloss format and style, on the contrary, hold significant appeal. While artists working with video have no visible inclination to produce the serial dramas or documentaries — much less game shows and news spots — common to television, neither do they display the 1970s objective of challenging the artifices of television by recording the "truth" of single moments or events in "unmediated" form. Generally, artists now have access to, and make full use of, sophisticated editing and postproduction equipment; slow-motion, superimpositions and multiple images on a single screen, computer-generated forms and the flipping of elements or objects, manipulation of colour and playing with depth-of-field and audio capabilities, have all become common, and their use underlines artists' intentional construction of the image. Flirting with and commenting upon mainstream conventions and traditional narrative forms now mark video.

Nonetheless, a first generation of video artists continues to develop and explore language (where earlier they had investigated more visual and formal aspects through works based in Performance and Conceptual Art). In Tom Sherman's three-hour *Exclusive Memory* (1988) in black-and-white, versioned both as single-channel tape and multi-monitor installation, the artist is constantly on-screen, a "talking head" performer seen from several camera views. In this "exclusive memory" the viewer becomes conscious that he/she is receiving programming-informa-

tion — if that is the term — simultaneously and coincidentally with an unseen robot. Fact and fiction are entwined in a complex manner, as with all good stories.

Sherman's video, like that of Colin Campbell and many others now working with the medium, depends primarily on verbal play. His *TVideo* is a wry commentary on the "truth" tropes of earlier video, and implies discussion of viewers' assumptions about the "personal" nature and meaning of their own relationships with TV hosts and performers. Sherman's mix of source materials and presentation leads his viewers to take his fictions as "non-fiction" — and the reverse.

In the work of certain other artists, however, a *nonverbal narrative* pertains. Actions and images are strung together without accompanying dialogue, so that visual evidence and pacing alone must indicate meaning, often through processes of association and inference. In preparing *Quartet for Deafblind* (1986, 88 minutes), Norman Cohn revises traditional documentary modes to seek understanding and "truth" through experience, and his viewers come to share both that experience and the particular revelations, visual and emotional, that he has recorded on tape.

NARRATIVES AND FICTIONS

Time and linear progression are a requirement for video; they invite the use of narrative. At the same time memory and ongoing (new) experience are stored as individual and collective compilations of narrative fragments. History as well as fiction has relied on narrative, a means of making sense of past, present and perhaps future. "Truth" is a variable constant, open for redefinition and investigation. It is a slippery ideal, perhaps impossible.

Words, images, sequences in motion, all propose a kind of truth, whether explicit or implicit. All narrative is finally fiction — a construction of will, desire, memory, fantasy — a serious business, yet an arena for play. In video, the early works were direct, aiming at "truth" through transparency of language and reliance on simple and very basic tools. Recent pieces are structurally more complex, built on sophisticated narratives, both visual and verbal. But to tell the truth? Never a simple matter.

NOTES

An earlier version of this essay was written in 1991 and first appeared in *Texts* 9 (Winter 1993) under the title "To Tell the Truth: Narrative and Fiction in Artists' Video."

1 Roland Barthes pointed out the role of the reader in constructing any text. His work and "reception theory" in general has subsequently been given close attention and elaboration by others ("Death of the Author," in *Image-Music-Text*, trans. Stephen Heath [New York: Hill and Wang, 1977]). With regard to television, considerable research has queried manipulation of the audience, primarily through editing and pacing of programming/commercials. One of the most popular texts on this subject has been Jerry Mander's early *Four Arguments for the Elimination of Television* (New York: Morrow Quill Paperbacks, 1978). The passage of time, of course, affects any response: *I Love Lucy* will "mean" different things in 1990 than it did 30 years earlier. Ads, too, date markedly, as Muntadas' collection of *Political Advertisements* (1988) taken from television spots by and for American presidential candidates 1956-88 demonstrates.

2 James Clifford, *The Predicament of Culture* (Cambridge: Harvard University Press, 1988), p. 10ff.

3 John Grierson, *Grierson on Documentary*, ed. Forsyth Hardy (New York: Praeger, 1971), p. 146-147. Quoted in Trinh T. Minh-ha, "Documentary Is/Not a Name," *October* 52 (Spring 1990): 78.

4 Joyce Nelson, *The Perfect Machine: Televison in the Nuclear Age* (Toronto: Between the Lines, 1988), p. 47-57, outlines the development of the classic TV series from the early 1950s, with particular attention to the "crime series" and "sitcom" formulas of the 1980s.

5 Pauline Kael's term for the filmgoer's sensation of being swept away by the larger-than-life actions projected in a darkened cinema.

6 Nelson, *The Perfect Machine*, p. 69. In 1969, researcher Herbert Krugman found through repeated tests of TV viewers that, after only 30 seconds of TV viewing, their brain-waves switched from predominantly beta waves, indicating alert and conscious attention, to predominantly alpha waves, indicating an unfocussed, receptive lack of attention. Nelson discusses additional research done in monitoring the brainwaves of television viewers (p. 69-73). Advertisers' reactions to this data are outlined (p. 73-84).

7 See Richard Serra's videotape, *Television Delivers People* (1973), discussed on p. 26. Several artists' works have noted the effect of TV assumptions and environment, a more recent example being Lisa Steele and Kim Tomczak in *Working the Double Shift* (1984, 18:30 minutes), which demonstrates the ways in which television's representations of individual and family relationships, values and experience are ideological constructions. By isolating and naming media messages and value systems, Steele and Tomczak offer a critical rereading of the television text.

8 Bruce W. Ferguson, *Colin Campbell: Media Works 1972-1990* (Winnipeg Art Gallery), excerpted by the National Gallery of Canada for their exhibition programme pamphlet, 1991.

4

NARRATIVES

Cornucopia

A cornucopia is a "horn of plenty," associated with harvests, abundance, prosperity. Fruits spill voluptuously from its open mouth, an affirmation and proposition of flow. General Idea's *Cornucopia* is a colour videotape from 1982, 9:53 minutes in duration and existing equally as a tape, a published illustrated text and as a component in a sculptural installation of 1983. It is a multiple-format narrative work.[1]

The major visual elements of the videotape are (a series of) seven revolving ceramic cornucopiae, set against a Chroma-key blue ground punctuating a sequence of black-and-white drawings from the ruins of the *1984 Miss General Idea Pavillion*, and found in "the room of the unknown function." Isolated portions of a longer tale are intimated at once, as we are directed to "Imagine these shards as nodes of thought, imaged points of intersection erected in the network of motifs and themes from which the Pavillion is constructed and its fragments dispersed."[2] The audio track is a modulated mix of chanting female voices with piano and drum, and an extended voice-over commentary detailing the function and significance of the representations on-screen. The whole is briefly introduced by the chant, while a light plays on gauzy rose-orange curtains, and a male voice outlines a context for the drawings and objects to follow. The male-voice introduction with its objective point of view is separated

Opposite page above and below: Stills from *Cornucopia*, 1982, by General Idea. Photos courtesy of VTape, Toronto.

from the expository main body of the tape (with its female voice-over, more subjective and interpretive) by the title "Cornucopia/General Idea." The white letters swoop forward from screen centre before a brief cut to black, followed by the first of the *Pavillion*'s drawings.

The tape is structured simply, single shots edited end-to-end, though the transition from drawing to revolving sculpture is in each case accomplished by a "turning-page" effect, the last drawing folding forward to reveal the cornucopia-against-blue "underneath." The narrator's voice explaining each drawing pauses as the cornucopiae are displayed, to be replaced by a soft rhythmic drumbeat complementary to the phallic shapes. There is no camera movement while the drawings are presented, but after each circling cornucopia is shown full-screen the camera zooms slowly forward to focus on its tip. As the seventh cornucopia completes its cycle the screen goes briefly black, to be replaced by the rosy curtain of the tape's opening shot, and production credits roll upwards. There is no final flourish; a verbal summary has been incorporated unobtrusively in the speaker's final words: "The cornucopia acts as the ground for this final transformation: the artists' elixir of inspiration, in other representations pictured as the intellectual mix of the cocktail, here transformed into the intuition of the lunatic artist, coming like honey from the liquified moon." The important role of the voice-over in *Cornucopia* puts the tape firmly in the narrative camp; the text is linear, explanatory and logical in its development. These words illuminate the images, give them nuanced meaning and function. The narration provides basic and crucial information, and structures the tape both in its linear development (a string of words and images) and its nodal implications (the branching reference to further histories contained in each of the visual and verbal components of the piece). However, any actual storylike quality is very weak, for there is no introduction or development of characters, no apparent diegesis, no narrative closure. Rather, in a pseudo-scientific presentation of "true facts" and deductive reasoning, the tape uses a type of exposition characteristic of the ethnographic film.

General Idea readily acknowledge their appropriation of traditional formal devices for ironic and allegorical effect. With reference to ethnographic cinema, Bill Nichols has pointed out that "voice-over commentary tends to render the image track sub-assertive. It becomes a set of illustrations for conceptual points, presenting that information of which the explanation can most readily dispose." He reminds us that "pinning down a single image's meaning with words or other images" tends to "pin down possible meanings and perhaps not the most important meanings at all. Unresolved enigmas on the margins of expository commentary act as a vital cue to such a possibility."[3] On the one hand, the assumed authority of the voice-over tends to confirm attribution of meanings for the images as shown, and the text is taken at its word. Yet in this case the drawings and objects have been fabricated precisely as *signs* of a history and *clues* to an ontology, and fictional elements incorporated in the text and tape are made prominent. We are shown fragments from the "ruins" of the *1984 Miss General Idea Pavillion* in a videotape from 1982, a future-past tense that is wittily seductive. The 1984 *Pavillion* had always been projected for the future — until 1977, when photographs were published of the smoking ruins of an apparent building site and a completed edifice now already destroyed. Since 1977, new discoveries have regularly been made, mining the (lost) site for previously unknown — or new — objects. In fact, there has never been a Pavillion in literal, physical terms, but rather a selection of individual interrelated works, each one part of an imputed whole; it is the use of contradiction and juxtaposition that alerts us to the transformative nature of the material. Metaphor is presented as if it were archaeology, yet we are warned in the opening sentences of the introduction that "Accumulated layers of function and meaning slip in and out of focus, creating a shifting constellation of images which is the Pavillion itself." Face value is clearly not to be trusted, for no fact has a single meaning. Nichols' note that unresolved enigmas in the margins of a text may provide an indication of being offered only a convenient partial truth is here used quite deliberately. The text is to be understood as presented, in literal terms, but

we are simultaneously expected to detect its flaws of logic and fact.

MYTH AND SCIENCE

Nichols questions the use of explanation in ethnographic films, for he sees some form of essentialism too often at its base. This essentialism "in drawing on observation, proposes transparency between what is seen and the knowable: things are what they can be seen to be. . . . Thought attributions distill the ambiguity from mute images to give us the living essence."[4] For General Idea, however, ambiguity is multiplied — for the attributions of the literate voice track cannot be taken as valid. What has been isolated as problematic for ethnography — "a strange form of explanation for a branch of anthropology otherwise eager to uphold a differentiation between itself as science and the realm of myth"[5] — has been exploited by General Idea precisely to confound myth and science. In doing so they reinforce the "reality" of their construct while at the same time underscoring its function as myth.

Contemporary myth is the province of Roland Barthes, and General Idea have referred repeatedly to his work in pursuing their own. Barthes' *Mythologies* appeared in English in 1972 and was at once appreciated by General Idea for its application to North American culture, and to contemporary bourgeois experience and values everywhere. While others — Claude Lévi-Strauss, William Burroughs, Gertrude Stein, fellow artists — remained important sources, Barthes struck an especially responsive chord. His notation of the "empty, parasitical form" characteristic of myth and his avviso that "every object in the world can pass from a closed, silent existence to an oral state, open to appropriation by society"[6] was to be echoed often in General Idea's work of the 1970s, returning ghostlike in *Cornucopia* when "these ceramic objects extract meanings from images and spit out the empty shells — like these skulls waiting to be fleshed out by the act of recognition." Barthes' originality, persuasiveness and poetic eloquence were an inspiration, and informed the mood and stance of much of General Idea's written corpus of the

period; the addition of a singular and characteristic irony completed General Idea's image.

The first extended and specific evidence of their fascination with Barthes appeared in the important "Glamour" article published in *FILE Megazine* in the fall of 1975, though mythologizing culture and its icons had occurred in General Idea's "beauty pageant" performance pieces as early as 1970, becoming more fully articulated with the example of Barthes' *Mythologies* and subsequent texts. From *Mythologies*:

> Myth is a type of speech. . . . it is a mode of signification, a form. . . . Myth is not defined by the object of its message but by the way in which it utters this message. . . .

> . . . myth in fact belongs to the province of a general science, coextensive with linguistics, which is *semiology*.

> In actual fact, the knowledge contained in a mythical concept is confused, made of yielding, shapeless associations. One must firmly stress this open character of the concept; it is not at all an abstract, purified essence; it is a formless, unstable, nebulous condensation, whose unity and coherence are above all due to its function.
>
> In this sense, we can say that the fundamental character of the mythical concept is to be *appropriated*. . . .

> . . . any semiological system is a system of values; now the myth-consumer takes the signification for a system of facts: myth is read as a factual system, whereas it is but a semiological system.[7]

In *Cornucopia*, the story of General Idea is told — again — through fragments from an ancient history. Sculptures, drawings, recreations of ruined settings, the emblematic poodles and water images are linked together as background to the cornucopia: prosperity and phallic icon. All of these are signs of the *Pavillion*, the edifice embodying the story of General Idea as cultural emblem and grand narrative for "the Search for the Spirit of Miss General Idea." The setting in a distant past, the broken bits of culture preserved (as they were partially destroyed) by chance, the games of reference to a more topical present (the copyright sign scattered as border detailing, the cocktail glass

shattered as if by falling plaster) all point to a narrative written almost entirely in quotation marks. Each story leads to another.

The multiplication of elements and layers, repeated throughout this tape and referring back to sequences of earlier pieces by General Idea, enriches the texture of their tale and adds to its variety of "yielding, shapeless associations." While General Idea itemizes and recounts over and over the constituent parts of its composition, there is no doubt that the *Pavillion* with its shifting position in time, its continuing construction, destruction, annotation and deployment, "is not at all an abstract, purified essence; it is a formless, unstable, nebulous condensation, whose unity and coherence are above all due to its function." Myth is a container for narrative: the story is its necessary form of transmission.

Barthes stressed the necessity of repetition: "The repetition of the concept through different forms is precise to the mythologist, it allows him to decipher the myth: it is the insistence of a kind of behaviour which reveals its intentions."8 And General Idea, throughout their brief tape, emphasize the *Pavillion*'s proliferation of significant emblems, returning to images of the ziggurat, the spilled cocktail and the *Dr. Brute Colonnade* from earlier works; poodle threesomes and watery/pissing images are added here "for incorporation into the image vocabulary of the Pavillion." The cornucopia itself takes on the role of "mediating image," newly designated as sign. Every opportunity is taken to refer to or suggest ritual, custom, iconography in the structure laid before us, to ensure the reading of the work as allegory and myth. General Idea are to be taken as both originators and accomplices in this construction, for they initiated the elements and their interplay, carefully building up an edifice of signs, but as they are elements themselves in this myth, they are available in turn for deconstruction from the outside: inhabitors of as well as commentators on.

Irony is at the centre of General Idea's *Pavillion* and all that it stands for. The *Pavillion* is a model for the museum, and "the room of the unknown function" in *Cornucopia* is its recreation in miniature. Since 1968, General Idea had laboured to construct their Pavillion, tongue-in-cheek but entirely in earnest, and now,

surrounded by artifacts, they portray themselves as a trio of fancy canines, commenting:

> The poodle, because of its effete, banal image, its desire to be preened and groomed for public appearances, was an easy image to occupy. Emptied of its meaning by its passage through the cornucopia, it acted as General Idea's mannequin for their parading ideas.

A beauty pageant, a museum-like *Pavillion*, the Search for the Spirit, the memorializing and deciphering of ruins are all metaphors or allegories for production and reception of works of art, their place in and for history. One never anticipates the final, real completion of the Pavillion through construction or even destruction. The Pavillion is a system of values, a way of speaking. It is an allegory and a cloak, a form of open narrative.

A VIDEO WORK

All of this tends to emphasize the literary and philosophical qualities of General Idea's piece, but its primary existence as a videotape is not to be forgotten. Conscious as always of popular forms, of worldly desires and contexts, General Idea have chosen the format for *Cornucopia* from a possible range offered by commercial television. We have here a pseudo-documentary programme, a kind of television mini-special showcasing the artifacts of a lost civilization. For this videotape, the Pavillion has taken on the attributes of the ancient Villa dei Misteri in Pompeii, and the unmistakeably sexual form of the erect cornucopiae plays cleverly on the famous Dionysian rites enacted on Pompeii's frescoed walls. Sexuality and censorship have been a frequent issue for General Idea, the former an ongoing component of their work since the earliest days and seen especially in *FILE Megazine*, and the latter becoming explicit by 1979 with *The Anatomy of Censorship* performance and exhibition of photoworks. Pompeii's villa remained closed for years to unaccompanied women and children, and censors everywhere continue to hesitate over a celebration of the sexual. Ironically, commercial television is not subject to an otherwise customary (local) pre-censorship of film and video, apparently assuming the continu-

ing caution or inertia characteristic of TV programming norms. Though literal-minded watchdogs may find no fault with the material of *Cornucopia*, the issue is present and is clearly proposed in the tape. The comparison of videotape and television standards is equally implied.

Commercial television tends to rely on and support traditional values of thought and action, reinforcing the culture from which it springs. TV's language is that of its audience, the linguistic and conceptual forms familiar to everyone. "Television functions as a social ritual, overriding individual distinctions, in which our culture engages in order to communicate with its collective self. . . . Television performs a 'bardic function' for the culture at large and all the individually differentiated people who live in it."[9]

By comparison, the text of General Idea's videotape is dense and literary, but its mirroring of TV formats and its use of such comfortable direct-address phrases as "the objects you are about to see. . . ."[10] return us to that sensation of intimacy experienced with the TV set at home. The avuncular tones and fantasy images recall nothing so much as "once upon a time," promising new knowledge in the most familiar terms. The ambiguous time-frame, though unidirectional (without flashbacks or diversions), is similarly suited to a fairy tale mode. The omniscient narrator, while playing the part of scientist/guide, recalls also the mediator responsible for maintaining and furthering traditional narratives in ethnographic or preliterate societies. This narrator, a kind of *deus ex machina*, seems to speak from an impersonal base of knowledge and authority, not originating the message himself but transmitting essential wisdom to "his people." The narrator, then, is a single example of that bardic role played by television more generally, and General Idea in *Cornucopia* have isolated and put into play one of the fundamental bases of the television medium.

The producers of commercial television do not formally design or conceptualize TV as societal mediator, carrier of cultural norms and values. Seeing itself as an "entertainment" medium, part of the communications industry, TV's primary purpose is more often to sell the products of its advertisers, thus supporting

its continuing activity and attracting new sponsors. This point has been made often — it is hardly a new insight. In situations where television is not properly a commercial enterprise, rather an arm of the government and responsible to it for financial support, TV's function is nevertheless analogous and a support for the status quo. Its logic is that of the marketplace, aimed at everyone, and rests with the codes of an oral culture. Closely reasoned argument and a literate syntax using specialists' language have never found a place in a television assumed to be ephemeral and of "mass" appeal. All the more reason, however, for the power of the spoken word, the visual example, the short-form overview. Television is our new source of opinion, of history; it is a sharing of information, and in this sense is truly a means of communication.[11]

General Idea have taken these forms and filled them with a very different content, beguiling us nevertheless to slip into a mood customary to regular television. That their strategy is effective demonstrates the mythic or bardic role of television as a medium, and their own inhabitation of a newly spawned mythology. It is equally a part of their myth that *Cornucopia* is "real" television.

NARRATIVES

Classical narrative may be seen as "a special form of the invocation of desire and the promise of gratification in an imaginary time and space peopled by characters performing actions around whom and by whom enigmas are posed."[12] "Narrative," actual and implied, is a term usually associated with storytelling: recounting a series of events or representing an occurrence, but narratives work in other ways as well, partial and vestigial "stories" leading us to fill out what is given from the store of our imagination. We would seem to crave resolution. Roland Barthes has pointed out, indeed, that even a simple sequence of events is an intelligible narrative,[13] and while such a sequence must have a point of commencement and of ceasing, there will not necessarily be that assumed beginning, middle and end, the sense of unity and moral purpose effected by full narrative closure. Hayden White distinguishes between narration of facts and *narrativ-*

izing them. While the latter is a way of imposing the form of a story[14] on elements of history or the imagination, there is no concord regarding the limits of narrative.

In Western society we tend to think in words, and explain the world (or justify actions) through stories, that is, sequences of events placed in meaningful order. Civil law is based on precedent, that is, on earlier examples of similar situations with known or acknowledged outcomes that provide examples — answers — for later like instances. Children are taught by example too, with nursery rhymes and bits of history mythologized, cautionary tales or retold fragments of their parents' or home environment's experience. All these techniques are narratives. And parts of a story will recall its possible completion, suggesting its present relevance.

Words and stories seem immediately available and comfortably familiar. Probably they offer the easiest way to share ideas — and artists' performance pieces, installations, photoworks (perhaps all formats and media) have learned from literature, theatre, daily habit. There has been a lot of storytelling in video, whether diaristic or theoretical, and any meaningful argument requires logic (sequential reasoning) as well as development through time.

More specific to the present issue, video is linear, for its empirical construction is similar to its ribbon-like form. It is necessarily sequential, the experience of even a single field requiring time for the bright point of light to trace back and forth across the raster to form an image. One cannot isolate a single "hard" frame, but only a record of the tracing dot-forming-lines-of-light-and-shade. Each "still" image is in constant motion and renewal; this flow (rather than a chain of discrete images, as in film) is a fundamental condition of the medium.

When one factors in the video's continuous audio track, the inference of oral culture and tale-telling, the intimacy of revelation by an omniscient (unseen) narrator — understood in the light of contemporary mythologies — we can see narrative as natural, even inevitable for video.

Cornucopia is a multiple narrative, our exemplar.

NOTES

An earlier version of "Narratives" was previously published in *Parachute* 41 (December 1985) and *Video by Artists 2*, ed. Elke Town (Toronto: Art Metropole, 1986).

1 The illustrated text is virtually identical with the tape's script and drawings. This text (script) is published in the exhibition catalogue by Elke Town, *Fiction* (Toronto: Art Gallery of Ontario, 1982), and reprinted in full in General Idea and Jan Debbaut, eds., *General Idea 1968-1984* (Eindhoven: Stedelijk van Abbemuseum, 1984). The installation piece was part of *Museums by Artists* (1983-84), an exhibition originated by Art Metropole and circulated in Canada by the Art Gallery of Ontario.

2 General Idea, "Cornucopia," in *Fiction*, n.p. All quotations from the videotape are from this source.

3 Bill Nichols, *Ideology and the Image* (Bloomington: Indiana University Press, 1981), p. 267, 269.

4 Nichols, *Ideology and the Image*, p. 274.

5 Nichols, *Ideology and the Image*, p. 275.

6 Roland Barthes, *Mythologies*, trans. Annette Lavers (London: Jonathan Cape, 1972), p. 109. First published by Éditions du Seuil, Paris, 1957.

7 Barthes, *Mythologies*, p. 109, 111, 119 and 131, respectively.

8 Barthes, *Mythologies*, p. 120.

9 John Fiske and John Hartley, *Reading Television* (London: Methuen, 1978), p. 85.

10 Here, one of the minor modifications of the video script for its publication as a written text; *Fiction* replaces this phrase with "the objects reproduced here . . ." to suit the new format and place-of-the-audience.

11 Colin Cherry, *On Human Communication* (3d ed.; Cambridge: MIT Press 1978), p. 30, quoting the derivation of "communication" from the Latin for "share," comments, "We do not 'send' messages, we always share them. Messages then are not goods or commodities, which can be exchanged or sent from one person to another. Thus, if I tell you something, I have not lost it — we now both have it whereas we cannot both possess the same article or commodity. Furthermore, you could tell it to somebody else, and so on." Television's advertisers, of course, intend the sharing of information about their products, which are certainly commodities.

12 Nichols, *Ideology and the Image*, p. 93.

13 Roland Barthes, *Writing Degree Zero*, trans. Annette Lavers (Boston: Beacon Press, 1970), p. 30. First published by Éditions du Seuil, Paris, 1953.

14 Hayden White, "The Value of Narrativity in the Representation of Reality," in W. J. T. Mitchell, ed., *On Narrative* (Chicago: University of Chicago Press, 1980), p. 2.

5

MEMORY WORK

Video: a performance in time. The listener watches, storing up images, assessing the scene presented, perhaps embellishing and "completing" the experience with details from life, from indispensable — constant — memory.

Memory is "a spacious palace, a storehouse for countless images of all kinds which are conveyed to it by the senses."[1] Classical and Renaissance scholars and orators — Simonides, Cicero, Quintilian, Giordano Bruno and others — taught that an imposing or familiar edifice, seen in "the mind's eye," could house composite images placed in order, as a technique for recording lists, texts, any sort of information. Ancient feats of memory may appear astounding now, but in the days before printing or even writing, some system of recall was crucial, and Frances Yates in *The Art of Memory* and Jonathan Spence in *The Memory Palace of Matteo Ricci*[2] offer evidence of remarkable individual accomplishments. Ricci (1552-1610), for example, not only knew by heart great sections of Cicero, Horace, Ovid, Homer, current advanced mathematics and astronomy and the mass of Catholic doctrine and liturgy, but learned to speak and write elegant Chinese in a matter of months. When his written sources were no longer available, he was able to reproduce them at will from his mental storehouse.

Today, memory is more likely a collection of photographs and film fragments, visual sequences played in the back of the mind, less facts than durations: the famous madeleine of Proust,

Opposite page: Still from *Delicate Issue*, 1979, by Kate Craig. Photo courtesy of VTape, Toronto.

or a familiar song reviving an old experience. For some, memory is an ill-lit attic filled with cartons of files, an endless succession of cards in drawers and cases, with facts too easily mislaid. For others, memory is a small disc, the information digitalized for quick scanning. Artist Tom Sherman, investigating computers and nonorganic memory systems, has called memory simply "a place to store the unfinished past." But the contents of the mind, both personal and more broadly cultural, continue to fascinate.

For video works — as for film, performance or installation pieces — memory is brought into play with the incorporation of a fourth dimension to the traditional three of painting or sculpture. Time-based, media works cannot be ingested in an instant, nor are they intended to be glimpsed briefly from a gallery doorway. Even a single viewing presupposes both duration and the short-term recall necessary for a summary overview. An "extended present" is established for viewing work composed in the past but presented "now." Judgment is simultaneously ongoing and held in abeyance until viewing is completed.

In looking at a painting or sculpture, the eye might roam over surfaces to judge relationships of shape and colour, assess technical control, consider the "story" pictured or rhetoric rehearsed. For media works, all this is compounded by the addition of time to space. As sculptor Robert Smithson wrote, "The continuous dimensions of space with all its certainties and rationalisms has broken through my consciousness into the discontinuous dimensions of time where certainties and rationalisms have little value. The calamitous regions of time are far from the comforts of space."[3]

For viewing videotapes, a literary suspension of disbelief is called into play; we believe the evidence of our eyes even at the expense of logic — hence a tension in the spell cast by moving images. Juxtapositions and contrasts, even "impossible" contradictions, may be linked in an apparently natural flow. Developing over time, these images exist as an automatic narrative.

Formally, video and installation works might mimic theatre, advertising or the news — implying a commentary on those formats themselves — and ideologically they may have any kind of

hidden agenda. But literature, theatre and mass media are perhaps no more relevant here than anecdote or personal history, which at least bring forward one's own memories, added to an accrued collective recall. The audience for video has a crowded scheme of references: a grid different from that of the originator of the piece, and likely different from viewer to viewer. Each individual carries along a lifetime of memories, even when they might be forgotten and inaccessible to the conscious mind.

Video and installation works may evoke dreams, fragments half-remembered. As Sigmund Freud has observed, "dreams are derived from the past in every sense. Nevertheless the ancient belief that dreams foretell the future is not wholly devoid of truth. By picturing our wishes as fulfilled, dreams are after all leading us into the future. But this future, which the dreamer pictures as the present, has been moulded by his indestructible wish into a perfect likeness of the past."[4] How apt this "dream" seems to a discussion of video works, which more than anything else are constructions of desire and the embodiments of future/past. Moreover, the very composition of a videotape recalls the dream-work itself with its condensation (fragments standing for a whole, elements omitted, disparate parts fused), its displacement (allusion, approximation, substitutions), its symbolic relations, and its transformation of thoughts into visual images. Wishes become apparent experience, and ideas pictures. We know that works of art are not in fact dreams, nor representations of dreams, but their gestation and significance may be illuminated by Freud's discoveries.

LANGUAGE

George Steiner argues the central importance of the tradition of high literacy—an assumed familiarity with the Greek and Latin classics through to Shakespeare, Goethe and the 19th-century novel—in Sigmund Freud's formulation of psychoanalytic theory.[5] Freud derived his illustrative material—inspiration and proof—from the canon of the "great tradition." His patients tended to be drawn from a specific social group, with a literacy and world experience much like his own; he constructed his

theories, his intellectual edifice, from his interaction with and projections onto these individuals. Language was central.

The artist's task is analogous to Freud's. While Freud intended "a universal, normative model of meaning and behaviour"[6] and the artist's aim is clearly less all-encompassing, more personal and individual, a reliance on language codes and a common ground of reference are fundamental to the exchange.

Consciousness itself is neither linear nor sequential. Nevertheless, a work of art may be considered a "text" and its viewer or audience the "reader." These terms suggest passive and active elements; the reader is not merely moving his or her eyes over a series of lines but is actually constructing meaning through experience of the work. The work of art holds within it the intentions and perceptions of its maker; the reader, considering the available elements, performs an ongoing translation and configuration. "Only by subjecting the text to a particular type of reading do we construct, from our reading, an imaginary universe. Novels do not imitate reality; they create it."[7]

In the ephemeral world of video and time-based installations, how complex is this translation, this construction of a world? The amplitude of information — images, sound, movement and change, the time consumed — prevents a reader's (or viewer's) full surrender to imagination, as does the physical presentation on page (or screen). But context is mental as well as physical, and includes the viewer's previous experience and the media environment itself. The world of commodities must intrude almost consciously into the substance of the work: "real world" memories.

RECEPTION AND RESPONSE

As Marshall McLuhan signalled in *Understanding Media*, television is a cool, participant medium: "The TV image is visually low in data. The TV image is not a *still* shot. It is not a photo in any sense, but a ceaselessly forming contour of things limned by the scanning-finger. The resulting plastic contour appears by light *through*, not light *on*, and the image so formed has the quality of sculpture and icon, rather than of picture. The TV image offers some three million dots per second to the receiver. From these

he accepts only a few dozen each instant, from which to make an image. . . . Everybody experiences far more than he understands. Yet it is experience, rather than understanding, that influences behaviour, especially in collective matters of media and technology, where the individual is almost inevitably unaware of their effect upon him."[8] For the text of television, a reader must be especially active, with eye and mind engaged on several levels to fill in visual and contextual data. For video, linked with other traditions and situated in a mass-media world of popular culture, we must question the form and logic of the response mechanism itself, the space between object and viewer.

In a related context, Tzvetan Todorov points out that "Reading is so hard to observe: introspection is uncertain, psycho-sociological investigation tedious."[9] Television viewing patterns and physiological response have been subjected to numerous studies. But what is it that links object — or experience — and viewer? What involves both mind and body, past and present? Without some such engagement there is little response, and the work may seem merely inadequate or incomplete. When these connections are made, what factors are in operation? Is the exchange physical, intellectual, psychic, or all of the above? Memory plays a key role.

Perception and biological recording of images in the memory were being studied long before we came to consider mechanical or electronic reproduction in the 19th and 20th centuries. Lucretius (c.100-55 B.C.), for example, explained "seeing" as the result of *films* streaming out from object to beholder, saying that

> replicas or insubstantial shapes of things are thrown off from the surface of objects. These we must denote as an outer skin or film, because each particular floating image wears the aspect and form of the object from whose body it has emanated.
>
> When our limbs are relaxed in slumber, our mind is as wakeful as ever. The same sort of films impinge upon it then as when we are awake, but now with such vividness that in sleep we may even be convinced that we are seeing someone who has passed from life into the clutches of death and earth. This results quite naturally from the stoppage and quiescence of all the bodily senses throughout the frame, so that they cannot re-

fute a false impression by true ones. The memory is also put out of action by sleep and does not protest that the person whom the mind fancies it sees alive has long since fallen into the power of death and dissolution.[10]

For the present discussion, it is ironic and revealing that Lucretius would choose *films* as the term to describe or explain the passage of information from object to perceiver. Even two thousand years ago vision and perception, memory, sleep and dreams were seen as interrelated. These same "films" were further understood as requiring an *active* perceiver, a reader of the text, as it were. And thus his words remain directly relevant to our investigations here.

> At any given time, every sort of film is ready to hand in every place: they fly so quickly and are drawn from so many sources. And, because they are so flimsy, the mind cannot distinctly perceive any but those it makes an effort to perceive. All the rest pass without effect, leaving only those for which the mind has prepared itself. And the mind prepares itself in the expectation of seeing each appearance followed by its natural sequel. So this, in fact, is what it does see. You must have noticed how even our eyes, when they set out to look at inconspicuous objects, make an effort and prepare themselves; otherwise it is not possible for us to perceive distinctly. And, even when you are dealing with visible objects, you will find that, unless you direct your mind towards them, they have about them all the time an air of detachment and remoteness. What wonder, then, if the mind misses every impression except those to which it surrenders itself?[11]

Lucretius considered the external object to be the source of visual perception and thus of understanding; memory also has its role to play. But what is happening *internally* for the viewer? What prepares that state of readiness for perception and understanding?

New art seems to engender a state of anxiety or psychic tension in its viewers. The work may be unfamiliar and full of questions, making new demands on its audience as it seeks its place in history. Freud called anxiety "unconsummated excitation,"[12] a fine term for this active response-state. However, even for Freud,

"It is the topographical dynamics of generation of anxiety which are still obscure to us — the question of what mental energies are produced in that process and from what mental systems they derive."[13] He construed anxiety, active response, as a shunning of the instinctual by the rational, a reasonable hesitation. Rather than pleasure, art may effect anxiety if it worries and excites. The mind attempts to make order.

One may keep experience (and thus anxiety) distanced by a buffer of secondary sources. We may *read* in preference to direct experience (check the review rather than see the work), or distance and commemorate via the photograph. In a similar manner, the personal spoken word is used for opinion or conversation, while "real" facts are written and read. As a literate society, we too often undervalue direct experience, even though the education and reference tools at our disposal may be inadequate substitutes.

In the preliterate world, oral memory kept history alive. "Oral verse," explained Eric Havelock in *Preface to Plato*, "was the instrument of cultural indoctrination, the ultimate purpose of which was the preservation of group identity"[14] — and played a part not unlike the television of today. For Homer and Hesiod, the Muses "are not the daughters of inspiration or invention, but basically of memorization. Their central role is not to create but to preserve."[15] Before Socrates and Plato, there persisted an "oral state of mind": a mode of consciousness, a vocabulary and syntax very different from today's print-referenced culture. Hesiod notes the pleasurable spell cast by the Muse upon her audience — a communion of drama, poetry, music and dance — and Plato describes the state of mind as a kind of sleepwalking. These analogies and approximations return over and over, and remain relevant to our study here.

Plato's *Republic*, perhaps the first text for a literate Western society, demanded a shift away from oral culture. The Greek word *psyche* came to lose its primary meaning of ghost or wraith, or a man's breath or lifeblood, and came to be understood as "the ghost that thinks," that is capable of moral decision and scientific cognition, a unique essence. For the first time individuality became not only possible but desired, and means of learning

changed radically; the psychic mechanism which exploited memorization-through-association was being replaced, at least for a sophisticated minority, by reasoned calculation. After this point, replication of a text (enacting it through memorization) could be replaced by a critical attitude towards information. Poetry and drama need no longer function as encyclopaedia and historic record; information could instead be open to question in a new way. Works of art might now be created by single individuals (rather than by collective experience over time) for specific and preconsidered purposes — even if there might be a subsequent division of artistic responsibilities in executing the final work. It was the shift from oral to written (recorded) memory that made such a change possible.

NEW MEMORIES

Libraries of written texts tend to be impersonal repositories, full of conflicting alternatives; the writings and ideas of many centuries are included today in our mental "furniture." Yet it might be said that today we have a form of "postliterate" culture, where computer links and data-base storage have reduced reliance on "hard copy," and telephone calls often replace the written note or personal visit. To many government planners, or even readers of newspapers, art has become Entertainment, just one component of the Cultural Industries.

With television, a new kind of identification takes place between viewer and viewed. As within oral cultures, the listener or speaker "becomes" the hero or heroine of the poem (programme), living vicariously. The actions depicted on TV — as with the epic poems of the Greeks — are the facts of the everyday and the heroic, where gods have much in common with mortals. For TV viewers — as if facing the icon of an oral culture — such common fare as *Sesame Street, Cheers, Star Trek*, or even the news, is full of contextual information and instruction; television most commonly affirms the status quo, even when despairing over aspects of culture or behaviour.

But *video*, while referenced formally to popular media, is not TV or theatre or the movies. It is not necessarily familiar or af-

firming, and plays an outsider's role, recalling the "anxiety" probed by Freud. In spite of video's "cool" television form, inviting involvement and identification, its message is analytical, disjunctive; the viewer is split into two simultaneous responses, unable to settle completely into either. Even when based on "entertainment" formats (like General Idea's television parody *Pilot* or their pseudo-scientific *Cornucopia*) these media works demand conscious and sustained evaluation. While they have language at their core, their argument may be neither simple nor linear. For viewers accustomed to lively commercial fare there is much that is "boring" or unreasonable about these works. Though not themselves television, they are products of the television age.

MEMORY AND TIME PAST

Memory IS; it is a present-tense state. Remembering happens in the present, though the things to be recalled have their place in the past. Family photographs have often truncated or replaced organic memory ("hard copy" being tangible, unchanging, visible on demand), and xerox has replaced the tedium of manual note-taking (though "having a copy" often substitutes for evaluation). The availability of material in libraries has removed the need for personally remembered history and literature. Reading is *as if* remembering, worlds previously unfamiliar being revealed page by page. And video offers new lives for old, tapping into contingent personal memories for colour and elaboration.

In "A New Refutation of Time," Jorge Luis Borges recalled that for the British philosophers Berkeley and Hume, time was a uniform flow of ideas in the mind, a succession of indivisible moments; Borges' own opinion, however, is "I do not know with what right we retain that continuity which is time. Outside each perception (real or conjectural) matter does not exist; outside each mental state spirit does not exist; neither does time exist outside each present moment." Going on to discuss the arguments for and against the divisibility of time, as proposed by F. H. Bradley, he ended by affirming the position of Schopenhauer, who argued proof for "only the present, not the future nor the past. The latter are only in the conception, exist only in

the connection of knowledge, so far as it follows the principle of sufficient reason. No man has ever lived in the past, and none will live in the future; the present alone is the form of all life, and is its sure possession which can never be taken from it."[16]

To Borges, poet and essayist, with great experience in exploration of the "imagined temporal," only the present was valid, though the past could be neither modified nor obliterated. The past was a *given* as memory. Yet he saw the present as unshared between individuals. Each of us is alone, unique, and living in a world both different from, and perhaps incompatible with, that of others. Yet in attempting to understand our construction of time, experience and memory, he points out that "All language is of a successive nature; it does not lend itself to a reasoning of the eternal, the intemporal. . . . Time, which is easily refutable in sense experience, is not so in the intellectual, from whose essence the concept of succession seems inseparable."[17] Media works, existing through time, are equally successive and similarly confounding.

Solitude is a fitting state for creation, no doubt its prerequisite, and one may surely be "alone" in the presence of others. To be supremely alone is to be supremely creative, divine. But to have a present without a past is madness itself,[18] a possible but truly horrifying state where no fact or individual has meaning or purpose, and nothing therefore can touch the inner self. For a sane mind in Western culture, the self is a construction of perceptions and experience; it is by and in memory that our "present" is formed. For artists' work in time-based media today—video and film, performance, installation works—memory can be access and introduction. Memory assigns and completes meaning: personal, cultural, in the continuum of history itself. One responds at once then, to the thoughtful words of poet bp Nichol, as he writes:

> why do we forget then spend our lonely alone times trying to
> remember there is so little real forgetting there is only
> misplacing or not wanting to recall not wanting to remem-
> ber oh i remember yes i remember now i remember
> ive remembered before this memory of rememberings pain-
> ful remembering the remembereds hard[19]

NOTES

An earlier version of "Memory Work" was published in *Descant* 60, 19, 1 (Spring 1988).

1 Saint Augustine, *Confessions*, trans. R. S. Pine-Coffin (Harmondsworth: Penguin Books, 1961), p. 214.

2 Frances Yates, *The Art of Memory* (Harmondsworth: Penguin Books, 1969), and Jonathan D. Spence, *The Memory Palace of Matteo Ricci* (Harrisonberg, VA: Viking Penguin, 1984).

3 Robert Smithson, "The Shape of the Future and Memory," in Nancy Holt, ed., *The Writings of Robert Smithson* (New York: New York University Press, 1979), p. 211.

4 Sigmund Freud, *The Interpretation of Dreams*, ed. Angela Richards, trans. James Strachey (Harmondsworth: Penguin Books, 1976), p. 783.

5 George Steiner, "A Remark on Language and Psychoanalysis," in *On Difficulty and Other Essays* (New York: Oxford University Press, 1978), p. 48-60.

6 Steiner, "A Remark on Language and Psychoanalysis," p. 50.

7 Tzvetan Todorov, "Reading as Construction," in Susan R. Suleiman and Inge Crosman, eds., *The Reader in the Text* (Princeton: Princeton University Press, 1980), p. 67.

8 Marshall McLuhan, *Understanding Media: The Extensions of Man* (New York: McGraw-Hill, 1965), p. 313, 318.

9 Todorov, "Reading as Construction," p. 77.

10 Lucretius, *On the Nature of Things*, trans. R. E. Latham (Harmondsworth: Penguin Books, 1951), p. 131.

11 Lucretius, *On the Nature of Things*, p. 155.

12 Sigmund Freud, *Introductory Lectures on Psychoanalysis*, ed. James Strachey and Angela Richards, trans. James Strachey (Harmondsworth: Penguin Books, 1973), p. 450.

13 Freud, *Introductory Lectures*, p. 454.

14 Eric A. Havelock, *Preface to Plato* (Cambridge: The Belknap Press of Harvard University Press, 1963), p. 100.

15 Havelock, *Preface to Plato*, p. 100.

16 Jorge Luis Borges, "A New Refutation of Time," in Donald A. Yates and James E. Irby, eds., *Labyrinths* (New York: New Directions, 1964), p. 230, 232-33.

17 Borges, "A New Refutation of Time," p. 225, 227.

18 As shown by Oliver Sacks in "The Lost Mariner," in *The Man Who Mistook His Wife for a Hat* (New York: Harper & Row, 1987), p. 23-42.

19 bp Nichol, *Journal* (Toronto: Coach House Press, 1978), p. 28.

6

IDENTIFYING CODES /
LEARNING TO SEE

A new medium begins by reiterating the conventions of its predecessors — only to break with them in asserting its own unique character, developing new conventions to structure its forms and materials.

Film, following theatre and vaudeville as it did, had two generative points: the experiments and surprise of Méliès (with laughing heads appearing "magically" in a room) and the proto-documentary approach of the Lumière brothers, the latter acting rather as Eugène Atget's views of Paris had in setting the terms for photography. As the "moving picture" developed further, *drama* assumed a central position, drawing on both theatre and the novel as framework for storytelling.

Narrative conventions for film were developed in the early years of this century; for English-language cinema these were due in large part to D. W. Griffith and his cameraman Billy Bitzer, who broke away from the "suitable distance" of film's theatrical point-of-view. Originally, the screen had simply replaced the stage, with the view of the camera analogous to that of a single spectator in an auditorium. But in *Birth of a Nation* (1915), for example, Griffith used isolation for dramatic empha-

Opposite page above: Norman Cohn, Leslie bathing, *Quartet for Deafblind*, 1986. Photo courtesy of the artist.
Opposite page below: Norman Cohn, Leslie watching TV, *Quartet for Deafblind*, 1986. Photo courtesy of the artist.

sis to show Lillian Gish's face in close-up, though it meant cutting off the rest of her body from view. The telling of stories had always had popular appeal, and fledgling cinema sought its own best way to develop and present dramatic forms.[1]

The growing importance of still photography in the late 19th century had set the scene for these developments. Framing — establishing visual boundaries for a work of art — is notably arbitrary; it is a conscious decision that includes or excludes any element from a given scene. As a mechanical means of reproduction, photography specified and made obvious the terms of that decision; composition in painting uses a similar process, but the camera's instantaneous freezing of a moment-in-time foregrounded the issue. Painters such as Edgar Degas or Henri de Toulouse-Lautrec, working in Paris in the final quarter of the 19th century, applied lessons learned from photography — abrupt cutting of figures and settings — to suggest this same "captured moment."

Traditional theatre presumes a framed stage — the site for the action of the story. Now film shattered the frontal imperative of that view and placed the spectator *inside* the action. Meaningful details were shown in close-up, and the viewer followed conversations through a sequence of individual heads with matching sight lines, accepting that the characters were talking to each other in a single time and place. One was drawn into the action by filmic structures that soon became conventions. For instance, the context of a telephone call could be established first by a long shot, then a sequence of telescoping details — a door, the inside of a room and finally, a mouth in close-up. Visual language of this sort has become the norm, and it is easy to forget how contrived a structure it is, how wilfully fabricated. Juxtaposition of shots through editing gives them connection; contiguity implies continuity for both time and location. It has become second nature for us to follow a text through such devices, and to immerse ourselves in a story placed before us.

ENTER TELEVISION

As an ephemeral, nonphysical and time-based broadcast medium, television's character owes much to radio. But because of its sequential images it is related to film as well and to the narrative conventions developed in film early in this century.

Television perfected the close-up shot, shifting its value from a radical statement for dramatic emphasis to one of fundamental convention. Small-screen and intimate viewing conditions make the "total view" inappropriate. So, capitalizing on the riveting quality of faces in close-up and combining these with rapid-fire montage (a technique first exploited fully by Sergei Eisenstein in *The Battleship Potemkin*, 1925), commercial television has become an extended exclamation mark. This visual structure is applied indiscriminate of content — advertising inserts, serial dramas, game shows, the news are all given much the same treatment.

The structuring of time compels attention — dividing and compressing, manipulating pace and direction. As rhythm and flow shape a listener's response to music, so a viewer's reaction to images may be energized by rapid cutting, enervated by languorous montage. Unedited "real-time" makes distraction easy, even inevitable, while controlled timing and location of events offer focus and a kind of syntax. Editing is a function of authorship, a means of shaping a story to acknowledge an audience and stimulate feedback.

Small-format video arrived after only two decades of commercial television.[2] Unlike the relationship of early still photography and painting or early film and theatre, early video did not reiterate the conventions of commercial television — an early independence the result, no doubt, of its origins in the Conceptual and Body Art of the 1960s and 1970s. Its roots were in social issues and the visual arts rather than entertainment or communications technology per se.

LEARNING TO SEE

The work of Norman Cohn offers a particular overview of development for one aspect of video, a microcosm for the documentary approach.

The videotapes of Norman Cohn seem simple: extended views of individual people, free of commentary and technological "footwork." Watching his tapes is an experience of *being there*, at once easy and disturbing. Easy, because we have immediate access to people in their regular environments — schools, hospitals, studios, homes — and they open candidly to us. But difficult because we are denied physical contact and exchange with these individuals, of whom we appear to have so direct and unmediated a view. Thus a certain tension arises as we recognize our position and responsibility: one cannot really respond to these people and their situations while still remaining a passive observer, a mere consumer of information.

We are dealing here less with an artist's personal development than with a single extended work in a constant process of becoming. Cohn makes videotapes that are portraits, studies of individuals in a finite period of time, in a certain location, undertaking specific activities. His stated intent has always been to see clearly, to acknowledge and preserve.

The early tapes (including 70 titles dating from 1977-78 shot in New Haven, Connecticut) were produced in black and white, each the measure of a reel of tape, i.e., either a half or full hour long. Content is somewhat arbitrary, in that, before starting to shoot, decisions had already been made about the number and length of the sequences, the intended overall duration. This structure seemed to Cohn a way to exclude personal intervention and "taste," and to give the work an objectivity. Pacing in the finished piece was fixed and interruptions were internal, resulting only from the physical activities of artist and subject. He allowed himself no editing or revision.

By 1979 Cohn had moved to rural Prince Edward Island, and some of the surface values of his work changed. He acquired a colour camera and editing equipment, and began to look outward for response. While many of the pieces retained the half-hour

span, all were edited for content and form. The works could no longer be described as "six sequences of five minutes, over a five-hour day"; rather, they depended on characteristic gestures or significant events. Moving outside the previous environments of school, home and workplace, Cohn initiated a series of *Children in Hospital, Children in Daycare, How We Lived*, as portraits of a period or a unique individual. The tapes were offered for sale to institutions and television, no longer intended solely for closed-circuit viewing by participants in the recording process.

These new tapes were still single portraits. While the camera moved in closer and became more intimate, Cohn maintained his distance by continuing to eschew dialogue. He was an invisible, silent participant in these contracts: an "eye" looking at someone looking back. *Peter in Long Term Care* (1979, 29 minutes) is one of the most striking of these pieces. At two years old, Peter cannot speak, but his eyes, his gurgles, his intelligent attention leave no doubt as to his character. One feels sure that little Peter is looking back through the camera lens at us now as we watch, though of course this is impossible.

Norman Cohn gives us a kind of history, but the "story" has neither plot nor action. His videotape *Lucy Brown*,[3] for example, is a portrait of a particular woman living in an old-age home. We see her amid other people and events, and note that she is in a wheelchair. Though not appearing to be very old, she seems incapable of carrying out the simplest tasks unaided. She is fed, combed, moved about by others — sociable and articulate, or withdrawn and confused. Lucy Brown is a small child again, or still, defenceless against the world around her and against her own past. In her own way she is a tragic figure, presented without commentary.

Yet the arrangement and pacing of events over the tape's 39 minutes have been carefully considered. From the opening line, "Are you my grandma?" addressed to her roommate (later revealed to be her sister), the viewer attempts to decipher this person. Although her mind appears childlike, she is a compendium of experience. Is she someone's mother, someone's wife? Who was she 20 years ago?

In this portrait of Lucy Brown, every "old age" is implied. Cohn presents the particular to evoke the universal, with striking effect.

This narrative is no traditional documentary. The sparseness and particularity of the visual facts on screen, the response of individuals to the camera's presence, insist on the veracity of the recording. This information appears too ordinary to be a fabrication, the people too transparent; one begins — through these images — to understand the quality of this life before us. Cohn observes, and through him the viewer is witness to situations, materials, events. Cohn attempts to achieve his own invisibility, plotting the viewer's recognition and response through a narrative which is constructed visually.

Nonverbal information is not particular to video; the evidence of visual signs can be the most dependable proof or evidence of *fact*, and is customarily more trusted than spoken testimony or *discussion*. But traditional television profoundly mistrusts silence, to the extent that any audio blank longer than a few seconds is accompanied by visual assurance that there is no broadcasting malfunction. It is unusual, even unsettling, to see an extended video image without commentary or supplementary audio track, and without stated message or aim — yet all the while one is sure that this information, this "programme," has been carefully structured. An active viewer, rather than a passive consumer, is called for. It is the second-order judgement, operating without conscious direction, that yields a reading more complex than the mass media's customary information transfer.

Jean Piaget, in *The Principles of Genetic Epistemology*, stipulates that:

> whereas certain philosophical schools, for example the logical positivists, have overestimated the importance of language for the structuring of knowledge, it is clear that knowledge, with its logico-mathematical and physical bipolarities, is formed on the plane of action itself as actions become coordinated, and subject and objects begin to differentiate themselves through the progressive refinement of mediating structures.[4]

Piaget is discussing the first formations of knowledge, but his ideas are directly relevant to our debate. As learning proceeds in the child by "repetition, recognition and generalization,"[5] so the adult viewer comes to terms with the material of nonverbal narrative. Knowledge is formed on the plane of action, and "conscious awareness proceeds . . . by selection and representative schematization, which already implies conceptualization."[6] Words alone are inadequate. Given elements of direct experience in Cohn's videotapes (unmediated by commentary, although constructed through editing and montage), we bring into play all our faculties of perception. The scene is dense and intimate, both witness to the individuals and circumstances deployed before us on screen, and challenge to our ill-informed assumptions and limited knowledge — of both self and other.

While it might be supposed that video such as Cohn's is simply a version of *cinéma verité*, there is an important difference in the "packaging" surrounding the traditional documentary form. One is expected to learn and to experience the results of learning. Yet *In my end is my beginning*, the five-part work which includes *Lucy Brown*, is by no means to be subtitled "Geriatric Care in Newfoundland," nor is it likely to prompt sentiments about the grace of growing old. Although our reading of these lives depends on the elements of Cohn's framing and construction, with its subtle qualities of light and texture, the careful and reflective placing of events, one suspects no coarse voyeurism on his part. Though lacking a traditional dramatic structure, this is clearly no random "slice of life"; balance and process are at work, as are a conscious eye and mind. Cohn attempts to transmit experience, a crystallization of observation rather than a determined response.

His development of *nonverbal narrative* in video remains unusual, and it is an area he has continued to explore. Cohn's choice of subjects is strategic, for in fact these students, or children or old people, are not the prime content of his work. Cohn does not portray individuals for the sake of description or identification, nor does he study their situation inside institutions — classified by age, health or occupation — for information about

social progress or social roles. His project is larger and more fundamental. It is a search for the roots of the human, the means of seeing oneself and one's world. His choice of video as medium is also strategic. Seeming to unfold in the present, it can address "dangerous" subject matter (the inevitability of death, the privacy of pain) and the banal (daily rituals, normal routines). Viewers can hardly remain simple observers.

Cohn uses surprise as an underlying premise. While television offers mass-cultural entertainment as a public communications medium, video, as employed by Cohn, offers the most intimate glimpse of private individuals. Television engages us by multiplying edits and fragmenting scenes; Cohn relies on long, quiet looks, extended sequences where time becomes almost palpable. Our normal assumptions and routines are upset "in order to create a unique perceptual window for the viewer"[7] which frames reality and alters it to a hyperreality. "It is the window that counts, not what's on the other side of the window."[8] Children or babies at the start of life, or old people facing its end, show us an enhanced sense of time. Cohn records people at points of change, in a situation of extremes — even if that condition is for them an unexceptional state. By privileging us with access to that state through his camera-eye, Cohn invites the viewer to reconsider his or her own situation. Video for Norman Cohn is not a means of expression, it is a record of perceptual research. He continues to excavate the same ground, and in doing so, produces consistently "new" evidence.

Since the completion of these individual portraits, two important new developments have surfaced in Cohn's work. In 1986 he released *Quartet for Deafblind*, an 88-minute study of a group of nine- and 10-year-old children, deaf and blind since birth, living together in an institution in Nova Scotia. He had spent several days living with them, and the tape shows these boys and girls as they go to school or watch TV, roller-skate or eat lunch, brush their teeth, have a bath or swim and get along as they do each day. He hoped to discover their experience of the world, their understanding of it and themselves.

Perhaps it was the extremity of difference he found there, the world so unlike his own. Perhaps it was the happiness and normalcy of their lives, despite all odds. The tape is almost wordless, but is suffused with ambient sound; it is brilliant with light and subtle shadow, a sense of sight's approximation. Though the artist doesn't appear on screen, it is clear that for his subjects this time (remarkably) Cohn is no invisible and silent eye behind a lens. For the final six minutes, nine-year old Leslie takes the camera in his own hands to complete the work he understood Cohn was making. It took Cohn two full years to complete the editing for *Quartet* — and it was the last "author's" work he would produce.

Since 1988 Cohn has worked collaboratively as a member of Igloolik Isuma Productions in Igloolik, Northwest Territories. With Zacharias Kunuk, Paul Apak and others, a series of tapes is being produced showing Inuit life and culture, for circulation "down south" and abroad via festivals and screenings, and throughout the North via the Inuit Broadcasting Corporation. Most remarkable is the series of drama/documentary works beginning with *Qaggiq (Gathering Place)* 1989 and *Nunaqpa (Going Inland)* 1991, recreating life on the land two generations ago, before the Inuit were relocated into towns and villages. The scripts and events are developed collaboratively by the video-makers and their "actors"; the language spoken throughout is Inuktitut, with subtitles in English or French. This group of tapes is also the basis for a longer series of half-hour programmes set in 1945 entitled *Nunavut*, self-produced with government financial assistance, and in production by 1994-95 for subsequent broadcast.

With these developments, we find reconfirmation of that early sense of "being there" as a viewer, as a participant (of sorts) in the lives before us. These portraits have a greatly expanded range of concerns, a more complex set of demands placed on the cultural, personal, historical information being shared. They address material and lives more unfamiliar than before — possibly "exotic" — and are developing an ever-widening audience, yet they continue to require an engaged viewer

who responds with conscious attention and interpretation. Cohn's practice, and his working with others, remain a single extended work in a constant process of becoming. A record of perceptual research. Learning to see.

NOTES

An earlier version of this essay, "Learning to See," was published in *Norman Cohn: Portraits* (Toronto: Art Gallery of Ontario, 1984).

1 This highly compressed reference to early cinema, and the place of Griffith and Bitzer in the development of narrative conventions for film, are developed at length in a larger consideration of the field and its options for the artist's "voice" by Bart Testa, *Back and Forth: Early Cinema and the Avant-Garde* (Toronto: Art Gallery of Ontario, 1992).

2 The situation of television vis-à-vis video recalls the parallel existence of the film industry and "underground" or "experimental" cinema: large-scale, mass-audience moneymakers versus the small-format, low-cost (and often special-interest) independent works.

3 *In my end is my beginning, Part 2*, 1982, colour, 39 minutes. (From a total of five parts, 3 hours, 10 minutes in length.)

4 Jean Piaget, *The Principles of Genetic Epistemology* (New York: Basic Books, 1972), p. 24.

5 Piaget, *The Principles of Genetic Epistemology*, p. 23.

6 Piaget, *The Principles of Genetic Epistemology*, p. 25.

7 Conversation with Norman Cohn, 30 November 1983.

8 Cohn, 1983.

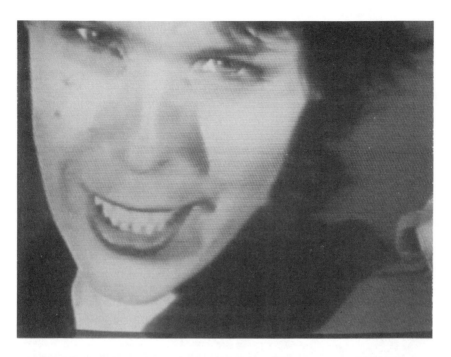

7

THE USE OF THE SELF
TO STRUCTURE
NARRATIVE

The Self is complex, made up of both conscious and uncon-
scious. As vital principle or *psyche* it constitutes identity, a
distinct mental and spiritual entity coextensive with but inde-
pendent of the body or *soma*. The Self is the integrated unity of
subjective experience, a result of decisions and actions taken
over time. The Self is a locus for events, a battleground —
through the body — for id, ego and superego. And the Self is a
symptom of a specific culture, the source of social adaptation
and also its effect.

The Self has its place in artists' video, though on terms of
ongoing change since the first works of the late 1960s. When
Rosalind Krauss posited "the medium of video is narcissism" in
1976,[1] isolating "the two features of the everyday use of the
word 'medium' that are suggestive for a discussion of video: the
simultaneous reception and projection of an image, and the hu-
man psyche used as a conduit,"[2] she specified the central place
of the human body — most often the artist's own — in video pro-
duction. That body was positioned between camera and moni-

Opposite page above: Susan Britton in *Me$$age to China,* 1979. Photo
courtesy of VTape and Art Metropole, Toronto.
Opposite page below: Elizabeth Chitty in *Telling Tales,* 1979. Photo
courtesy of VTape and Art Metropole, Toronto.

tor, the two machines functioning as parentheses for the record-
ing and re-projection of the performer's image, simultaneously,
as if on a mirror. Early works by Vito Acconci, Richard Serra/
Nancy Holt, Bruce Nauman and others were cited as examples,
when it could still reasonably be stated that "self-encapsula-
tion — the body or psyche as its own surround — is everywhere
to be found in the corpus of video art."[3] While the video screen
functioned as formal arena, it was often for information of the
most private or confessional sort, the reification of an inner self.

As the decade of the 1970s progressed, performance-for-the-
camera offered less evidence of self-absorption. Though the art-
ist continued to be present behind the scenes, on the monitor
and in the editing room, the body was severed from the psyche
to stake out a separate existence. The Self had "gone public,"
taken a role in the third person, become part of a scripted narra-
tive. It was an observant ego, declarative and politicized, that
continued to develop a particular kind of performance work for
video over the 10 years to follow.

THREE ARTISTS

Kate Craig uses the camera in its classic function, as simple re-
corder of a scene or view in apparent real-time. But two works,
separated by three years, indicate a dramatic change in the art-
ist's intention. *Still Life* of 1976 (30 minutes) shows a room full
of artifacts: silk shawls, shells, plants. The camera pans over sur-
faces and shapes while an Indian hand-instrument provides an
underlay of sound; this "moving portrait" is a wordless evocation
of personality.

Delicate Issue (1979, 12 minutes), by comparison, is exclama-
tory in its content, for the camera focusses on crevasses of skin,
nostrils and earlobes, tiny hairs and moles, the surface of the art-
ist's body (identified only in the tape's credits at the end, but in-
dicated by a consistent use of a first-person voice-over text). We
hear a regular breathing and heartbeat. But the tape is no ingen-
uous exposure, for a gently insistent voice-over queries:

What is the dividing line between public and private?
At what distance does the subject read?
How close can the camera be?[4]

The quiet tone specifies a willed display of everything . . . or nothing at all, for what we see is mere surface. Though we are given an apparently complete tour of her body, all we have learned is its colour and texture. Jonathan Swift's description of a similar landscape in *A Voyage to Brobdingnag* is a literary forerunner:

> The nipple was about half the bigness of my head, and the hue both of that and the dug so varified with spots, pimples and freckles, that nothing could appear more nauseous: for I had a near sight of her, she sitting down the more conveniently to give suck, and I standing on the table. This made me reflect upon the fair skins of our English ladies, who appear so beautiful to us, only because they are of our own size, and their defects not to be seen but through a magnifying glass, where we find by experiment that the smoothest and whitest skins look rough and coarse, and ill coloured.[5]

Referring more particularly to the confessional idiom of early video, Craig affirms:

> The closer the subject the clearer the intent.
> The closer the image the clearer the idea.
> Or does intimacy breed obscurity?

Revealing "all" can remain unsatisfactory. In effect, "if I show you everything, what will you understand?" Having given us her body as open territory, she denies the value of that access:

> How real do you want me to be?
> How much do you want?
> How much do I want from you?
> When do you cut out?
> When do I cut out?
> At what distance does the subject read?
> This is as close as you can get.
> I can't get you any closer.

She tests the point of saturation. *Delicate Issue* deals in "tissue" but also questions interpersonal exchange: public and private,

known and unknown, the line of division is never clear. Video is a form of communication, mind-to-mind, and here we are offered flesh — via the disembodied electron. The medium remains cool. *Delicate Issue* gives us a "landscape" with accompanying admission of boundary, for Craig alone cannot complete either information or knowledge. Though seeing is believing, it is also inadequate.

Her action is generous, yet it demands some form of return:

> When do I stop sharing?
> How much do I want from you?

In this she remains an active subject in the videotape, not simply an exposed object. This first-person is a position of strength and active will, director of actions.

Object and subject play different roles in Elizabeth Chitty's *Telling Tales* (1979, 26:30 minutes). The artist takes an equally central position on-camera, presenting her body and its parts, clothed or otherwise. The video camera is her means for acting out a range of fantasies. As someone aiming to deconstruct language, investigate communication, Chitty relies here on blunt sexuality and an overloaded visual syntax to double up on her points. *Telling Tales*, like her later videotapes, is full of bravado: she demands that the viewer judge her, she flouts the role of strong woman in favour of sex-as-power, power-as-danger.

Yet Chitty too is obsessed with facts, with construction:

> The beginning of her story was the fact that she felt obliged to make one. . . . She felt an urge to observe the sequence of events, to make order of the information all around her. She would have to appoint certain things as the most important, as essential to her theme. Indeed, she would have to decide upon a theme, develop a credo, come up with an impeccable purpose. . . .
>
> To continue the story. She couldn't read the table of contents. She didn't know how to divide her story into paragraphs. She felt unsure about sentence structure. How should she choose a vocabulary?[6]

Narration in *Telling Tales* is constant, Chitty reading for us as she crosses off the sentences, litany of disaster:

> You get lung cancer from cigarettes.
> Birth control pills give you cancer or a stroke. . . .

Until we descend to:

> Rock music makes girls pregnant.
> If you step on a crack it'll break your mother's back.

She folds her hands, speaks directly to the camera:

> Have your answer sheets ready please.
> No. 1: What political event directly led to World War One?
> No. 2: What was the turning point leading to the crash of '29?
> No. 3: Why did the League of Nations not support the
> antifascist cause of the Spanish Civil War?

leading all the way to

> No. 20: Out with the facts! Let's get the story straight!

Though visually and circumstantially *Delicate Issue* and *Telling Tales* differ radically from one another, they have much in common. Their juxtaposition of physicality or sexuality with didacticism, their questioning of jurisdiction for public and private, their assault on the conventions of commercial television, are fundamentally political. Chitty continues to imply reference to TV formats such as melodrama, educational pieces, even the soft-core pornography of late-night movies. But in each case expectations for these genres are thwarted or inverted: this melodrama has no hero or heroine and the story never develops; this educational text devolves into childish superstition, this would-be porn never goes beyond its early masturbation. Chitty and Craig both reject sentiment, and continue to call into question their own actions and assumptions throughout their respective works. By undermining their identities, they propose an alternative to "just the facts." As Chitty summarizes: "Watch out for spontaneous thought. And don't dish out any cheap psychology."

Susan Britton takes a more ironic line on politics. *Me$$age to China* (1979, 23 minutes) opens with a blurred close-up of implied Orientalism: a woman's face with lowered eyes, black hair, her face white, lips red, wearing a brilliant blue blouse. The camera roves over her face, her fan, across flat colour surfaces,

as a male voice-over speaks in Chinese and a female voice makes a halting and inadequate English translation. Cut to the same face in sharp focus, not Chinese at all (and revealed in the credits to be Britton herself), as she speaks sharply to the camera:

> What is Authority?
> (insert: Me$$age to China)
> What is Privilege?
> (insert: Me$$age to China)
> What is an Executive Source Disc (smiles) with
> Zap Emulator?[7]

Cut to hands with lacquered nails on a control panel, a light background of piano and xylophone as Britton returns with a shiny crimson cloth:

> The new banner for NOW is polyester! Lightweight, washable, and wrinkle-free. We've received your message, we want to learn from the bourgeoisie. Our reply: will that be Cash — or Chargex? The dialectic moves in mysterious ways. The highest stage of capitalism is HERE. [she picks up a rolled poster to brush against her face. It reads, "V.I. Lenin. Imperialism, the highest state of Capitalism."] . . . But so is Cablevision! In the 70s, the only alternative was terrorism. Ultimately reactionary. [a close-up of a handgun. The gun is cocked, and a man takes it]. . . . and you in China were left with a 60-hour work week and insufficient hardware. In the 80s, East meets West. Let's reinvent politics together! Hi, China! Hi, China! Hi, China! Hi, China!

We see newsreel footage of U.S. President Carter hosting Deng in America, and we see "another" Britton in leather jacket and jeans watching the dragons and firecrackers in a parade for Chinese New Year, talking about her (fictional) "upcoming concert tour" to China: "those international boundaries, you know, rock'n'roll does it, it doesn't matter who it is. . . ."

As we watch an impassive Deng watching, Britton's voice-over speaks quietly, in traditional sign-off fashion, as the last word "brought to you by . . .":

> The dialectic certainly does move in mysterious ways.
> China invaded Vietnam last night.
> This has been a videotape by Susan Britton. . . .

In fact, Susan Britton has had a formal involvement with politics and ideology. She was an active member of the Communist Party of Canada, Marxist-Leninist, in the early 1970s and her early tapes vacillated between an ironic luxury-style advertising format such as *In the Mood* (1976) and the existential *Interference* (1977) or *Light Bulb Goes Out* (1978) which offered a bleaker vision of the world to come. *Me$$age to China* combines the two roots in a cynical (even bitter) send-up that nevertheless underlines the issues at hand. It is plain that China's policies could no longer be understood as blameless idealism; they were too pragmatic, if unpredictable. Exactly a decade later the events in China calling for "democracy" and a change of leaders which resulted in the massacre in Tienanmen Square, Beijing (June 1989) were to confirm the worst fears of the West regarding Chinese communists in power. In later works, Britton continued to address the impact of mass media on culture and ideology, and moved to New York where she worked in video and with cable television, but by the mid-1980s she had abandoned video altogether in favour of freelance writing.[8]

ON SCREEN

Kate Craig's use of the first person in the text is the root of her authority. Both voice and body are that of the artist, as we learn from the final credits; by performing or acting on her own she speaks directly. "I" am the source of this work and this knowledge; "you" are viewing me with my permission. Though Craig takes her place before the camera, as if a passive object, the voice-over text makes it plain that the decisions taken are her own, and the camera "eye" is hers by proxy, as it were, for it is she who is responsible for script and direction. It is this demand for self-presentation that is at issue here, NOT an interest in surveying a naked body; for this reason the use of actor or actress would have been inadmissable, fundamentally altering the function and meaning of the tape.

Elizabeth Chitty, by comparison, plays expositor. We are deluged with information. This speaking-person plus readable-text are reiterated on two on-screen monitors, re-emphasized by

the visible playback deck and microphone, underlined by the episodic format. The several stories are interwoven, the personae overlaid one upon the other. Yet for all the systematic use of third-person narrative, the (often-contradictory) characters could represent facets of Chitty's own make-up: "She was always telling tales." A transcription of the rock'n'roll selections in this video-tape would make a similarly revealing script. All the concerns are quotations from elsewhere, borrowed temporarily: a long sequence of admonitions.

Susan Britton's role on-screen differs from the first two, though she too considers public/private, popular culture and media clichés. Her layering of visual and verbal texts presents a more literal consideration of political issues. She plays Oriental, translator, advertiser, terrorist, artist, rock musician, citizen and reporter. It is only in the final subdued voice-over that the tape's (originary and) central point is made:

> China invaded Vietnam last night.
> This has been a videotape by Susan Britton. . . .

In *Me$$age to China*, Britton's position is neither first nor (specifically) third person. She inhabits a number of functions and points-of-view, combines off-the-air footage and street material with contrived reality from the studio, giving the whole a lightness and variety that serve to underscore the bleakness of her final statement. Her tape seems less "personal" than those of Kate Craig or Elizabeth Chitty because it is turned outwards more directly to the world of events; it incorporates media materials without commenting on them as such, while the other two seem specifically conscious of television facts and assumptions.

In each of these cases, the artist has taken a central position, image as well as auteur. We continue to find the language of the communications media under scrutiny, individual identity played off against social (and commercial) expectations in other works produced, as these were, by artists-in-residence at The Western Front in Vancouver, and these are issues that continued to surface through the early 1980s in performance-based video more generally. The model of TV itself is scrutinized for story

formats and editing decisions, but it is always ironic, overstated, and juxtaposed with specific content and pacing that are idiosyncratic. These themes become more overtly political, for they go against what we expect of any broadcast fare. Television is pictured as cultural ritual.

IMAGE AND AUTEUR

In these videotapes we see the artist turning towards the world to consider problems well outside her own psyche — using the self as intermediary to confirm a presentness for observation, to give an urgency to commentary. These artists are confronting cultural dilemmas and reflecting social imbalances through a construction of ironic media works in the most basic, pervasive cultural frame today. That these works are called video rather than TV is to say only that they are noncommercial.

In the early videotapes cited by Rosalind Krauss, the artist attempted to confront the inner self, to discover a logic of action and reaction. The fundamentals of perception were sought on two fronts: how does the human physical apparatus function, and in what way does psychic reality govern response? The tapes she considers were made in New York or Los Angeles between 1968 and 1974, and now may be seen to exemplify the then-current Performance, Body Art, Conceptual works. Video was framed in those days by a formalist aesthetic.

"Modernism has understood that the artist locates his own expressiveness through a discovery of the objective conditions of his medium and their history. . . . In distinction to this, the feedback coil of video seems to be the instrument of a double repression: for through it consciousness of temporality and of separation between subject and object are simultaneously submerged."[9] But with hindsight these statements may be reconsidered. The objective conditions and their history for video include those surrounding commercial television, as well as those issues of space, time, sound, light, texture and "presence" in film, theatre and the visual arts.

The lessons of the early video works are part of the history of the medium, and by the end of the 1970s the Self had become a

tool for narrative. The tapes were extended performances for the artists constructing them: moral tales, grammars and vocabularies, portraits and theses. For the viewer, they present the construction of knowledge. The artist's body, central pivot of the action, is author and originator, while his or her ego is the motivating principle.

NOTES

An earlier version of this essay was published in *Western Front: Vidéo* (Montreal: Musée d'art contemporain, 1984).

1 Rosalind Krauss, "Video: The Aesthetics of Narcissism," *October* 1 (Spring 1976): 51.
2 Krauss, "Video," p. 52.
3 Krauss, "Video," p. 53.
4 Statements by Kate Craig are transcribed from the spoken text of the videotape *Delicate Issue* (1979, colour, 12 minutes).
5 Jonathan Swift, *Gulliver's Travels* (New York: Garden City Books, 1945), p. 84.
6 Statements by Elizabeth Chitty are transcribed from the written and spoken text of the videotape *Telling Tales* (1979, colour, 29:30 minutes).
7 Statements by Susan Britton are transcribed from the spoken text of the videotape *Me$$age to China* (1979, colour, 23 minutes).
8 Elizabeth Chitty had studied dance and choreography, first making use of video as a performance element. The issues addressed in *Telling Tales* were taken up in subsequent works such as *Dogmachine* and *Desire Control* (both 1981) and *T.V. Love* (1982). Since then she has concentrated on larger multi-media performances, and is producer and artistic director of Cultural Desire Projects, often working collaboratively with others. Kate Craig continues to work in video, more recently having completed *Ma* (1986, 16:47 minutes) and *Mary Lou* (1989, 28:12 minutes): both works addressing visual patterning as well as giving visual form to spiritual concerns. She remains director of the video production studio at the Western Front in Vancouver.
9 Krauss, "Video," p. 58-59.

8

THE PROBLEM OF

DESCRIPTION

To describe: to give a verbal account of, to say what one sees (or feels, or thinks, or hears, or smells).

We may say that description presupposes judgement. At the same time, however, description *allows for* judgement or interpretation, it establishes terms and events in a field of enquiry, indicates issues and gaps and transforms visual and auditory facts into verbal ones, as a first stage in discussion. But we understand that this brings its own problems, not the least of which are the nuances of language itself on the part of both speaker and audience.

Rather than anticipate problems in the abstract, let us consider a single example. *Rhea* (1982) by David Askevold is a colour videotape 6 minutes and 50 seconds long. I select this particular work because of my own response on the first viewing and my curiosity about what caused that reaction, for very little seems actually "to happen" in the piece. When I tried to describe it to myself afterwards, I found it difficult to locate the relevant facts, or even to remember precisely what had taken place.

We have access to two "official" descriptions of this piece. From the 1982-83 video distribution catalogue of Art Metropole in Toronto, prepared by staff members there:

Opposite page: Still from *Rhea*, 1982, by David Askevold. Photo courtesy of VTape, Toronto.

Rhea — Colour — Stereo
1982, colour, sound
 A drama/narrative by implication. The tape, in part, features facial gestures and singular enunciations (by a variety of people with different ethnic backgrounds and sexualities) carry the plot.

From their catalogue of Fall 1984 (after a change of staff):

Rhea 1982, colour, stereo, 6:50 minutes
 Rhea opens and closes with a wandering spotlight, a wandering "I," in a saturnine and oblique interior. Faces appear against vague landscapes or without setting. A continuous panning movement links the faces, allowing them to combine in essence, then in form. They speak the names of others: as the visages transform, the "other" implied in the spoken name loses otherness and all names come to denote a commonality and singularity.

The first entry states that the work is a drama with a plot, if only by implication. The second names neither form nor genre. Its description seems more psychological, reading intention into the work and predicting sensation on the part of the viewer, whereas the first is more impersonal, though using a term such as "drama" reveals a decision to place the work in a particular cultural context.

 Such catalogue descriptions are aimed at potential purchasers and programmers. They invite interest and curiosity, and are intended to suggest a possible role or use for the work rather than a critical placement of the piece in history.

AND "MY" DESCRIPTION

A dark interior as the opening shot, with a circular orange-pink "travel spot" tracing along an interior warehouse wall, over boxes and unidentifiable shapes. Light music played on an instrument that sounds like a xylophone or electric piano begins simultaneously with the image. The single word "RHEA" appears superimposed on this background in blue capital letters, slightly seriffed. Some sort of event is suggested by the music and an indication of suspense in the setting. (What the artist consciously includes is supplemented by what the viewer brings to it).

There is time to summarize the scene and to read the title over a few times. Though the music continues without a break, the scene cuts to an unpopulated landscape, maybe a desert, and to a sequence of single heads in front of separate backdrops or the distant mountain range. The camera movement itself has not changed, being a silent travelling shot past the row of heads, always from left to right with the landscape and shapes/colours as backdrop. After perhaps a minute a clicking, humming machine-like sound is added to the music, suggesting tractors and roads. The heads do not move or speak, though muffled names are being spoken, one at a time in a questioning or reflective tone. Then the clicking stops while the music continues for a further half-minute.

The music ceases as the scene changes to images of single heads one at a time against a blank backdrop or wall. The camera moves into close-up on each face as the head turns, and the music begins again. Each individual says a single name as the camera moves past. The camera angle is oblique, the heads often on a diagonal relative to the frame, and the eyes are watchful. Then direct frontal views of single heads follow as the music continues. About three more minutes have passed.

Now there are numerous heads in a room and portions of bodies, shoulders and upper torsos, as the camera goes into motion, rotating, rising, circling around the models. There are no voices as the episode moves forward; the heads and bodies superimpose, phantom-like, as the camera moves forward and back in the space. The camera is attentive to eyes and lips. There is no visible response or rapport. Another minute passes in this way.

The screen goes black, then faint flecks of light appear in dark space — probably reflected from a turning mirrored ball — as the music returns. The light flickers have replaced the people in the warehouse interior with the pink spotlight travelling across the boxes and other mysterious shapes. The voices return with muted giggles, and single names are whispered, fragmentary, remnants of the last whirling scene: one can hear "Cilla," "Barbara," "Sarah."

The camera returns briefly to a sunlit desert landscape, panning slowly left to right across the scene as a different kind of music is heard: long notes on an electric piano with a quiet back-up beat. Just as the single sweep is completed there is a quick glimpse of photographed figures in the sky, superimposed on the landscape but shadowy, unreal. The landscape too is perhaps a photograph, for the texture and colours recall that flat paper surface, then the camera cuts again to a dark interior with the bodies of two people moving together, hands side by side, not quite touching. Cut to black. After a pause come the production credits, white letters on the black field, lower case in the bottom left of the screen, and the tape is over.

INCOMPLETE

There is more to be said. We have here a written account of events and images, and some of the accompanying words and sounds, but questions remain. Some of the answers may be found by talking with the artist or with people involved in the production and editing of the tape.

But first the work's name, so suggestive a sound. "Rhea" is the name of one of the Titanesses of Greek mythology, the daughter of Uranus and Gaea, and wife to her brother Kronos. She was the mother of Zeus, Poseidon, Hades, Hera, Demeter and Hestia. A rhea is a South American bird, rather like a small ostrich. And Rhea is the name of a town in the southwest United States, which the artist admits he chose at random from a map.

The plan for the videotape was a couple of years in gestation, and Askevold began with rather vague ideas about what he was after, with many additional possibilities in mind at the start. As work progressed and the first shooting was accomplished, he began to reduce and clarify his intentions. He had put an ad in *Now* magazine (a music/theatre/art/entertainment tabloid in Toronto), seeking models of all ages and ethnic groups for photographic and video work, and his instructions to those responding were simply that they should present themselves "however they wanted to be seen" and to choose make-up and adornments with this in mind. The warehouse scene had been shot first in an

acquaintance's large cluttered studio/storage space, as a test for camera, lighting, possible environment, then the scenes with the models (Askevold always referred to the people as models, never as actors) were shot at Trinity Video, an artist-run video studio in Toronto. He started with about 30 to 40 models and first took still-camera photographs of each of them in single sessions to test their suitability and responses. Over a two-month period he then did the video recording, again in single sessions of at least an hour each, where he had the models look here, turn their heads there, raise their eyes, etc. Each model was given identical instructions. Finally there were a couple of sessions where several of the models returned to be put through their paces again in groups; altogether about 13 hours of visual material was recorded.

During the same period, Askevold was working on the music, which he composed and produced on a Casiotone, a small electronic keyboard with a memory. Sound — apart from the names spoken "live" by the models during shooting — was added during the postproduction stage, when all superimpositions, freeze-frames and special effects were also edited in. A cityscape had been painted as backdrop for the studio sequences, but was rejected after preliminary shooting. Instead, Askevold used some of the mural-scale colour photoworks that he had made in 1978-79 based on landscapes in Nevada, Arizona and New Mexico.[1] This "recycling" of images and artworks is very much in keeping with his practice over the years. Slide pieces, music, photoworks, films, videotapes, texts have often returned in different forms for different purposes in his work. In *Rhea* the edges of the photographs or changes in image within single representations were camouflaged by editing, so that generally the photomontage backdrop read naturally in the tape, but Askevold was not concerned about making the illusion precise and hence permitted such discrepancies as the figures in the sky towards the end of the tape. Video recording in general was kept simple, with Askevold himself doing the camerawork and friends with whom he had often worked in the past functioning in the control studio, helping with scheduling and collaborating on the editing

and sound mixing, etc. None of this information was evident in the videotape itself (except through the credit mentions) but it does add to the description of the piece.

I have tried to mention all of what one sees and hears in this videotape. This elusive short work remains intriguing, though even after close scrutiny there is little of character, event or "message" revealed as content. Are formal qualities sufficient explanation for its continuing appeal? The facts on their own seem to have slipped over the important points, and additional information holds little promise of resolving my problem. Contingent circumstances colour experience, and I suspect that the artist encouraged such contextual elements as components in both construction and meaning of the work.

There was nothing didactic or fantasy-like about *Rhea*; I had thought of it as a story, and throughout the screening was expecting something to "happen." I was on the watch for clues, weighing each factor as it appeared. The tape seemed a fragment, with "the rest" of the story hidden or remaining to be told. When queried, Askevold said that was not his intention. And it is true that a sense of the fragmentary, of allusion and implication, is characteristic of his work in general.

In *Rhea*, dialogue and action have been reduced to mere cues. The spoken text is a sequence of single names or fragmented murmurs. Events consist in circumstance and situation, and in somewhat diminished terms; the desert landscape, the cluttered warehouse and the blank wall all offer suggestive settings. Eloquent and attentive eyes indicate a response to others. To other characters? To unheard directives? We are kept at a remove by the suppression of detail, but the conventions of narrative urge the pursuit of meaning.

Narrative at its simplest is a sequence of events over time, and the viewer attempts to link these in a causal relationship or to give them some significance. In *Rhea*, then, the landscape and people and cluttered interior may be related to each other. The music continuing through the tape, often overlapping its changes of setting, further ties the images together, and the dark colours, smooth camerawork and even pacing seem additional

confirmation of unity and deliberation. Each speaker, in repeating a single name, seems to savour a memory, and the searching light of the warehouse interior seems equally to review and remember. These responses are romantic, but Askevold has invoked ambiguity and allegory as a consistent strategy in his work:

> there is never one available meaning although there is a preferred range of meaning implied. It is difficult to say that the interpretation of something and that something itself must be independent of interpretation if the interpretation process itself is not to fall apart into arbitrariness. Or I wonder if it is too ambiguous to ask whether all interpretation contributed by the mind can be taken away, leaving a pure sensed given which leaves interpretation incompatible, denying sensible interpretation.[2]

Just as he rejects a single meaning, he encourages an intuitive response, and entering into the work: "If the totalization is to be grasped, it cannot be through analytical rationality which involves the assumption of a perspective of complete exteriority."[3] We are urged to accept the fragments of his work precisely for their discontinuity: "Recognizing the juncture between sets of messages when they occasionally meet, provides the necessary information."[4] Juxtapositions of information can illuminate by their very element of surprise. The conventions of film narrative — matching sight lines, strategic use of close-ups and image sequences — carry a story along and build anticipation. They permit a viewer to understand a text without words, to assign meaning to action and reaction. Manipulation of viewers' response is to be assumed.

With *Rhea*, Askevold chose to look at the way people want to present themselves, and a consideration of broader cultural values is not out of place. These models were preparing themselves to be on TV. Which of television's conventions and norms would prevail?[5] *Rhea* is full of talking heads, tightly framed: there is virtually no other human representation in the tape. The convention employed here is a vacant one asking to be filled — for we are obviously not looking at a talk show, an interview or the news. All the faces are attractive and "interesting," conjuring up multiple pasts.

Even those who are not watchers of daily soap operas will know something of their existence and form. They have become a contemporary icon, so successful during their years of afternoon existence (first on radio, then TV) that opulent evening versions were initiated with male as well as female audiences in mind — powerful personalities, byzantine relationships and improbable intrigues. The stories progress at a snail's pace for it is *process* rather than conclusion which fascinates, and the techniques of "meaningful" fact have become familiar to the most casual television viewer. In an issue of *Screen* magazine devoted to TV melodrama, the importance of the mise-en-scène was pointed out, and emphasis placed on the excessive emotionalism and operatic acting styles, the hyperintensity of confrontation as current custom. The serial form, without beginning or end and only temporary resolutions, subverts classical narrative structure to remove any possibility of final reward or punishment, for — like life itself of course — the story will continue the next day.[6] Askevold's tape takes this situation a step further. While his models do not act in a story, they retain the *indications* of melodrama — the charged glance, the anticipation — which combine with high-contrast lighting and music to suggest a narrative-in-action. The open ending, while giving no promise of return, also tends to comply with seriality so that the viewer is carried forward and then left waiting. . . .

Rhea is seemingly empty of event and its emotions and attitudes are fugitive. It is composed of cues. The viewer is given not actions but references, not personalities but the kind of portrait made familiar by contemporary advertising. Askevold's tape connotes popular culture by merest suggestion, but those reverberations inform an unconscious response.

INTERPRETATION

This essay attempts a description of a single artwork, already framed. Yet speech quickly reveals its "intrinsic inability to describe the smallest surface that our eyes can immediately grasp":[7] there is immediately and constantly an "excess of reality"[8] to consider. Any description is linked more to the vocabulary of the author than to the degree of complexity of the reality itself.

Yet no matter how evocative a description, facts and formal considerations are insufficient to the understanding of a work's impact on its viewer. Context too must be considered, a context which includes the entertainment industry, the history of commercial media and media-based and time-based contemporary arts. Drama, poetry and literature, photography and sculpture, performance and audio works are not irrelevant. Just as description of the work remains incomplete, so for context: *every* fact is potentially significant. Choices, therefore, must be made, based on (and permitting) interpretation of the work.

Since video exists only during playback in a sense, any description, even play-by-play (a version of simultaneous translation) must depend on memory. We discuss not objects but experience, an extended-present *in the past*. Experience being subjective, we acknowledge again the function of interpretation in re-presenting the work.

Interpretation as a term includes the conveying of meaning (of an experience) by performance, and it is also an oral restatement in one medium of what was said in another. A "translation." While this makes pliable the dictionary definition of "interpretation," it is easily seen that for video recordings, questions of *performance* and *translation* are central to the issue.

I refer then to Walter Benjamin's comments on the task of the translator:

> Is a translation meant for readers who do not understand the original? This would seem to explain adequately the divergence of their standing in the realm of art. Moreover, it seems to be the only conceivable reason for saying "the same thing" repeatedly. For what does a literary work "say"? What does it communicate? It "tells" very little to those who understand it. Its essential quality is not statement or the imparting of information. Yet any translation which intends to perform a transmitting function cannot transmit anything but information—hence, something inessential. This is the hallmark of bad translations.
>
> Although translation, unlike art, cannot claim permanence for its products, its goal is undeniably a final, conclusive, decisive stage of all linguistic creation. In translation the original rises into a higher and purer linguistic air, as it were. . . . The

transfer can never be total, but what reaches this region is that element in a translation which goes beyond transmittal of subject matter. This nucleus is best defined as the element that does not lend itself to translation.[9]

The "real" reason for my fascination with *Rhea* is that Askevold has constructed a *seemingly innocent work that nevertheless defies translation*. While appearing to follow "rules," it has been going its own way all along — and the viewer will never unveil the artist's original designs.

NOTES

This essay was first written in 1985 and was published in René Payant, ed., *Vidéo* (Montreal: Artextes, 1986). It has been revised for the present collection.

1 Part of the series *Ten States in the West* has been published in colour in the exhibition catalogue *David Askevold* (Eindhoven: Stedelijk Van Abbemuseum, 1981).

2 David Askevold, "Notes for Explanation and Attitude," in Peggy Gale, ed., *Video by Artists* (Toronto: Art Metropole, 1976), p. 30.

3 Askevold, "Notes for Explanation and Attitude," p. 31.

4 David Askevold, "Notes on The Ambit, An Introduction," in *David Askevold* (Eindhoven: Stedelijk Van Abbemuseum, 1981), p. 5.

5 David Antin, in "Television: Video's Frightful Parent," *Artforum* 14, 4 (December 1975): 36-45, discusses customary fragmenting of information and interlocking of programmes and commercials, but also the pervasive effect of this on ALL television content. "The smallest salable piece (of time) turns out to be the ten-second spot, and all television is assembled from it" (p. 39). In spite of the significant passage of time from the first publication of Antin's article, I believe his points continue to hold true.

6 Jane Feuer, "Melodrama, Serial Form and Television Today," *Screen* 25, 1 (January-February 1984): 4ff. Formal issues are not central to this article, but act as evidence to her argument that "the emergence of the melodramatic serial in the 1980s represents a radical response to and expression of cultural contradictions" (p. 16).

7 Jean Paris, *Painting and Linguistics* (Pittsburgh: Carnegie-Mellon University, 1975), p. 3, quoted in an unpublished paper by Carol Laing, "Description," 1984.

8 Paris, *Painting and Linguistics*, p. 3.

9 Walter Benjamin, "The Task of the Translator," in Hannah Arendt, ed., *Illuminations*, trans. Harry Zohn (New York: Schocken Books, 1969), p. 69, 75. First published by Suhrkamp Verlag, Frankfurt a.M., 1955.

9

A TABLEAU VIVANT

Video by itself is linear and evolving. A single tape moves sequentially from "this" to "that," whereas a video installation work (by comparison) achieves a form of continuation, if not development. Often cyclical in form, the installation repeats prerecorded material or generates a constantly new live image, responsive to its environment or to its programming. Customarily presented in a public space, its links are to sculpture and theatre, a form of *tableau vivant*. Nevertheless, in much installation work there are persistant vestiges of narrative.

An excellent example is Vera Frenkel's *Her Room in Paris* (1979), a sort of stage set from *The Secret Life of Cornelia Lumsden*, in which Frenkel pursues an investigation of such traditional forms as the Romance and the Suspense Thriller. The five videotapes included in this piece tell stories about (the possibly fictional) Lumsden — but their appearance on a television set in a dishevelled sitting room, surrounded by evidence of interruption (partly painted furniture, drawers ajar, open trunks and boxes) suggests the tapes are objects among other objects in a room, and incomplete on their own. The setting suggests a dramatic fragment, with the videotapes operating as something-on-television, that is, evidence that the room's occupant left recently, suddenly, without stopping to turn off the set. The tapes

Opposite page above: Vera Frenkel, *Her Room in Paris* (detail), 1979. Photo by Jim Chambers, courtesy of the artist.
Opposite page below: Vera Frenkel, *. . . from the Transit Bar* (detail) at Documenta IX, 1992. Photo by Dirk Bleicker.

are evidence also of a different sort, for they include information and speculation about Cornelia Lumsden, as to her whereabouts, her character, history and motives as given by various friends and "experts." In short, the video element offers *clues* — meaning and embellishment — to the stage-set or room in which they are playing. The "installation" element in turn gives logic and connection to the spoken texts (performances) on-screen. Neither is complete without the other.

Frenkel has continued to work with video in installation form, as in *The Last Screening Room: A Valentine* (1984) and *Lost Art: A Cargo Cult Romance* (1986) where, as she has said of herself, "She remains, first and foremost, a student of lies and truth, using them to reveal each other. She is doing this now, somewhere." At Documenta IX in Kassel (1992) . . . *from the Transit Bar* underlined the role of the viewer in constructing and completing the artwork, which played on society's long tradition of bartender-client empathy and exchange. Lies and truth being particularly endemic to alcohol, one was invited here to sit and relax over drinks in the midst of the exhibition hall, while several television monitors around the bar played an extended cycle of "talking heads" — of speakers/companions who were also in bars, or on trains, striking up desultory one-sided conversations. The voices spoke Polish and Yiddish — a highly charged choice for a German site at a time of mounting social and financial unrest. The subtitles (English, French, German) permitted almost everyone to understand the speakers — while underlining the polyglot cultural context. *From the Transit Bar* had several layers of *content* that could not be avoided or denied.

A related work at Toronto's Art Gallery of York University in the fall of 1993 continued the scene without video, with a player-piano tinkling lonesomely in a sheet-draped bar "after hours"; brief stories (excerpted from the *Bar Report*, Frenkel's document of stories told to her at the bar) were framed on the walls of an adjacent gallery space along with ambient photographs and objects. Frenkel's reference to television as comfort and companion (for others) places video against an everyday environment of anxiety and surrogate intimacy in the bar setting;

the *Transit Bar* installations both act as trope on the bleakness of—and need for—human communication.

Rather different are the narrative qualities of General Idea's *Cornucopia: Fragments from the Room of the Unknown Function from the 1984 Miss General Idea Pavillion* (1982-83). The installation was constructed as context (and elaborated pedestal) for an already completed tape, and incorporates the actual sculptures depicted on-screen in the video. Highly glazed ceramic cornucopiae revolve atop slender black columns arranged in a monumental ziggurat plan; the tape plays meanwhile on a monitor fallen askew at the foot of one pillar. While the tape on its own is a would-be documentary discussing recent archaeological finds, the installation with its sculpture plinths, carpeting and protective plexiglass, assumes the character of a museum display module. In this instance the tape becomes an "educational" or explanatory gloss to the architectural and design elements supporting and presenting it. The "museum as found-format" being discussed on-screen is demonstrated three-dimensionally (enacted) in the installation context.

Installations with incorporated videotapes establish a presence as *disembodied theatre*; there is a scene, an action, a story or event. While computerized interactive tapes can offer variety in a viewer's experience as, for example, *Family Portrait: Encounter with a Virtual Society* (1993) by Luc Courchesne,[3] most often the tapes used in video installations are programmed simply to *repeat*, to play a single part in the situation. The video element functions as a "live" character or personification, and as a source of information.

Spatial and sculptural factors (including props and furniture) might seem primary to establishing a theatrical context for video. Yet in an almost totally disembodied work such as *Keeping Marlene Out of the Picture—and Lawn* (1978) by Eric Cameron, both theatricality and apparent story remain strong. An otherwise empty gallery contains three monitors and a single terra cotta pot of common garden grass, all placed at eye-level on sculpture stands. Each monitor shows a tape recorded on location, from that monitor's point of view, i.e., each screen frames what is visible (as it were) "through" that screen. We hear footsteps in the echoing

room, the sound of purposeful walking as someone—Marlene, presumably—paces around, opening or closing doors. Each time she passes through the space of the monitor, the tape has been edited to keep her out of the picture (i.e., off-screen, invisible, no longer a participant in the story); the sounds, however, are clear evidence of her presence (and denotation of her removal). The pot of lawn grass sitting in the gallery (and visible on one of the monitors) functions, among other things, as a location point for the viewer. But the "real" action takes place in the viewer's mind as s/he anticipates but never quite sees the "other" inhabitant of the room, the present/absent Marlene.

An installation by Michael Snow, entitled *Intérêts* (created for *Art Vidéo Rétrospectives et Perspectives* in Charleroi, Belgium, 1983) takes a stance of calculated commentary. The "interest" in question could reasonably be that of the medium for the viewer, but also refers to the exchange value implied for artworks in general and by the TV medium in particular. At the Palais des Beaux-Arts the hands of the ticket taker and visitor are recorded by a camera installed above the entrance counter, showing the exchange of money for ticket. The first tape was recorded on the morning of the exhibition's first day and shown immediately on six monitors; further tapes were recorded on the second, fourth, sixth, eighth and tenth days and in each case shown the following day, in addition to the preceding tapes. A total of 21 monitors were gradually "filled" with the images of this financial transaction during the six weeks of the exhibition, and the six different tapes ultimately appeared simultaneously on six, five, four, three, two and one monitors. Response to this work was summed up in a letter to Snow from the exhibition's organizer, Laurent Busine (16 May 1983):

> For my part, I think it's one of the essential works. This work challenges completely the role of the artist, the role of the spectator, the relation of the spectator to the work, the position of the exhibition organizer, and the transit between the art, the effective creation of the work and the gaze of the spectator. In short, all the givens that make up the use of video by artists, overturning tradition in cultural habits.[1]

The Present Re-presented

Recorded videotape has fixed physical and temporal limits. But when a live camera-and-monitor are introduced, different qualities will emerge. Noel Harding's *Once Upon the Idea of Two* (1978), for example, has both a prerecorded tape (discussing the work's construction) and a live camera which invites a viewer to interact with the "set" and its looped film — by sitting in a chair, thus duplicating the film's action. The cooperating visitor appears on the video monitor as a double participant: a ghostly member of the film (being projected on a backdrop including the chair and its occupant) and of the black-and-white video which combines present action and film projection into a single scene, abstracted somewhat into monochrome.

Harding had used this mix of actual (live) and represented forms earlier, in his *Space for a Corridor Against a Door* (1976), where a viewer passed through a gallery doorway to find himself or herself appearing simultaneously on a video monitor just inside. On the reverse wall of the corridor entrance door, meanwhile, a black-and-white film was being projected, showing the artist life-size as he closed and reopened the door. The projected film was simultaneously combined on the monitor screen with the live image of entering viewer: a disconcerting confusion of time and space that juxtaposed shifting scales and perspective of the live and recorded figures. The installation managed to be a formal study in black-and-white, and a simultaneous self-confrontation in real-time.

Perceptual modes are also at issue for Dan Graham, in his use of mirrors and delayed closed-circuit video playback. The manipulation of response and countering of expectation have been at base for many of Graham's tapes and installations as, for example, the numerous versions of *Time Delay Room* (1974). Later proposals centred on issues of "public" and "private" at home, or in offices and commercial areas, and the interplay of information and desire encapsulated in television programming displays.[2] A decade later Graham was addressing issues of personal narcissism and a social self-consciousness: in collaborative performance/installations with Glenn Branca (Paris, 1985), for

example, the audience and the musicians could see each other only via mirrors and the monitors on time-delay; the audience watched itself as it tried simply to watch the performance. Graham's concern is to identify social constructs and habits, to articulate and comment upon human behaviour, and the immediacy of real-time video playback has been a form he has found ideal at many points over the years.

Video installations have an intermittant popular presence. An early Canadian example was the 11-part *Tele-Performance* series curated by Clive Robertson for the national *Fifth Network/ Cinquième Réseau* video conference in Toronto (Fall 1978). The 1980s saw such major compendia as *The Luminous Image* (Stedelijk Museum, Amsterdam, 1984) with 22 works by Europeans and Americans, and *Vidéo 84* (Montreal) with 18 installations. *Luminous Sites* (1986) presented 10 video-based installations and performances around Vancouver, while the first *Biennale of the Moving Image* (Museo Nacional Centro de Arte Reina Sofia, Madrid, 1990) included six installations with the many films and single-channel tapes. Single installation pieces are now often included in media-based exhibitions generally, and solo shows are being mounted for such international figures as Thierry Kuntzel (France), Stan Douglas (Canada), Gary Hill or Bill Viola (United States), who explore the form with a more ambitious investigation of what technology can offer, expanding the potential of video projectors, multiple images, computers and laser disks. Increasingly, slow motion and enormous scale are teamed to overwhelming effect: the physical qualities of the image have a comparable psychological impact on the viewer. At the same time, the sheer number of artists using media forms and formats makes it increasingly difficult — pointless — to compile comprehensive or representative lists of names and issues today. Form and content, hardware and software, scale, location and audience are all open to discussion.

Mounting such work is demanding, in terms of both hardware and technical expertise; the cost in dollars and organizational effort can be daunting. At the same time, their dramatic public presence is very appealing, and the tedious problems of scheduling

and awkward circumstances of in-gallery screening are obviated entirely. Installations have an open time-frame. As part of a three-dimensional construction the video elements are filled out by their sculptural "objectness" and completed by the timelessness of a museum or gallery setting; they replace a single viewing, head-on, with a *multiple access* afforded by their occupation of space and a continuing presence. The audience "completes" this work physically by interacting and experiencing it, walking around or through it, as they might a sculpture made up of several parts.

The difficulties and expense of mounting video installation works and arranging for their public presentation tend to limit opportunities for exhibition, in contrast with the bounty of the early 1980s, when there was a freer cash flow and more widespread experimentation with technology. Other technologies — robotics, virtual reality, satellite transmission, long-distance real-time video conferencing — are the darlings of the 1990s.

NOTES

An earlier version of "A Tableau Vivant" was published in *Parachute* 39 (June 1985).

1 In the original French: "Pour ma part, je pense qu'il s'agissait là d'une des oeuvres éssentielles. . . . Cette oeuvre . . . remet totalement en question le rôle de l'artiste, le rôle du spectateur, la relation du spectateur à l'oeuvre, la situation de l'organisateur de l'exposition, le transit entre l'artiste, la création effective de l'oeuvre et le regard du spectateur. Enfin, bref, toutes les données qui composent l'utilisation de la vidéo par des artistes, en bouleversant la tradition en les habitudes culturelles."

2 Dan Graham's video works and related writings from 1970-78 are illustrated and presented at length in *Dan Graham, Video Architecture Television* (Halifax: The Press of the Nova Scotia College of Art and Design, 1979).

3 Courchesne is one of the few Canadians to do *interactive* video installation pieces; this one has been shown in both Montreal and Toronto in 1995. See illustrations in *Press Enter: Between Seduction and Disbelief* (Toronto: The Power Plant, 1995), p. 149-51.

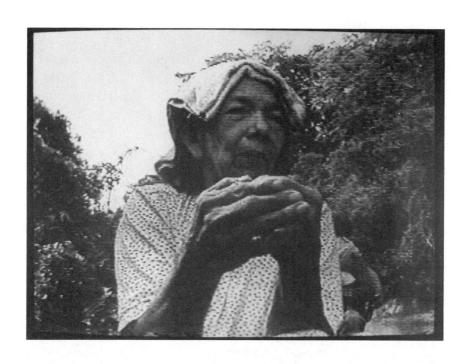

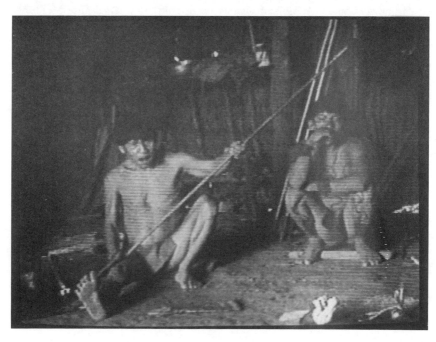

114

10

ANOTHER KIND OF
ANTHROPOLOGY

F rom the earliest days of Québécois video production, an ongoing commitment has been to analyze culture and identity. In effect, what was/is the francophone situation in Canada? Vidéographe (established 1971) provided one such focus for production and distribution of "alternative voices" via video in Montreal, and was an important centre for independent works despite its ties to National Film Board funding and politics. With related but different aims, a group of independent producers — Robert Morin, Lorraine Dufour, Gilbert Lachapelle, Jean-Pierre St-Louis and others — established the Coop Vidéo de Montréal in 1973[1] to buy their equipment collectively and work on projects together. Personal cultural politics rather than national ones have tended to be the focus of the tapes produced and directed by Morin and Dufour. They investigate a social "other," looking at misfits within the mainstream in an expanding portrait of their cultural milieu. The work relates interestingly to early films and videotapes by other Québécois, perhaps most particularly to those of Pierre Falardeau (whose early videotapes *Continuons le*

Opposite page above: Still from *La femme étrangère* (Helena Valero) 1988, by Robert Morin/Lorraine Dufour. Photo courtesy of VTape, Toronto.
Opposite page below: Still from *La femme étrangère* (Yanomami tribesmen), 1988, by Robert Morin/Lorraine Dufour. Photo courtesy of VTape, Toronto.

combat, 1971, and the 94-minute *Pea Soup*, 1978, lead circui-
tously to his 35mm features, *Le Party*, 1990, and *Octobre*, 1994).
But the combined voice of Morin and Dufour is unique.

Dufour and Morin study individuals and characteristic situa-
tions with an anthropologist's eye, though their field of study at
university was Communications. Moreover, they have side-
stepped the dilemma posed by Claude Lévi-Strauss:

> How can the anthropologist overcome the contradiction result-
> ing from the circumstances of his choice? He has in front of him
> and available for study a given society — his own; why does he
> decide to spurn it and reserve for other societies — which are
> among the most remote and the most alien — a patience and de-
> votion which his choice of vocation has deflected from his fel-
> low-citizens? It is no accident that the anthropologist should
> rarely have a neutral attitude towards his own group.[2]

For Morin and Dufour, it has been *precisely* their own group that
has been their prime object of study. Even their more "exotic"
subjects have clear relevance to or comment on the Québécois
situation (as well as that of francophones outside Quebec). By
considering the margins of their culture, they cast light on the
centre, and call into question the norm.

La réception

In this 77-minute work from 1989, viewers enter a house party
that turns nasty, where in the final sequences tables are turned
several times. Only as the credits roll with a traditional dis-
claimer (all characters and incidents are fictitious), do we see
Agatha Christie's[3] name mentioned, and realize that the mean-
ing (and structure) of *La réception* should be reconsidered.

Up to that point, it had been easy to view *La réception* as a
documentary work (real people, live camera). The tape opens on
a wintry river, speeding along in a boat to an isolated mansion
on the shore. Deposited at the landing dock, one approaches the
door of the house, opens, enters, looks around at a series of
near-empty rooms awaiting company: gleaming floors, a couple
of couches, a candlelit and white linen-covered table set for din-
ner. A lavish buffet and bar are ready, a fire in the hearth. As a

cork pops, our camera-eye turns to the source of the sound, approaches a small room to surprise a man opening a bottle of wine. "Who told you to come here? No one told me anything about filming the reception. No one warned me. It's a bit strange."[4] But then the doorbell rings and guests start to arrive in pairs, introducing themselves to each other in turn.

The point of view is that of the camera, and this camera has its own voice which enters directly into the conversation from time to time. A guest like the others, it watches closely, and the camera is addressed directly, or ignored, as "just" another participant. As events unfold, its role and opinion are challenged, its eye closed down (to re-open on a new scene). Its assessment of events is evident in the in-camera edits which mark each change in the action—edits accomplished by turning off the camera, then switching it on again later, elsewhere, the double-click sound evident and unmistakable. The viewer unconsciously registers this unusual procedure as evidence of improvised "live" recording. Whoever invited all these people together invited the camera too, "to film the reception." The camera(man) is no invisible outsider.

It's only later that, watching carefully, one notes that *some* edits, especially as events progress, lack that double-click shutdown, and must have been achieved afterwards in the studio. Nevertheless, the fiction of linear "live" recording remains established.

There are 11 plastic frogs in a row on the mantelpiece, and a printed verse on the wall above about what happens to them. Conversation is lively over drinks and a meal, though it is noted at an early stage that the phone doesn't work. Then a videotape is found and put on the player, where the guests are identified in turn: each is an ex-convict whose crimes and prison sentences are enumerated while the guest-camera surveys the others to register reaction. This is no normal party.

Darkness and snow are falling, and the talk turns to the past:

"When I was condemned to death, that's when I really
 started to live."
"Well, yes, I'm a transvestite but I didn't have the final
 operation."

"No, not me, I was never forced to make love with a woman."
"Violence, fear, here it's the same thing. . . ."

Without warning, one of the women is found dead in the next room. Was it suicide? She seemed fine when they were watching the tape. Murder? One of the frogs is noticed missing from the mantel. Dismay and confusion grow but it's late and eventually all of them go upstairs.

The group is trapped in the house by a snowstorm and howling winds; as the hours pass, others are found dead by the dwindling number of remaining guests. In a bedroom, in the snow, down in the cellar, alone in the pantry: those remaining realize that it must be one of themselves, but the culprit remains anonymous. Morning comes, time passes, another night: the sequence is confusing, but the deaths continue. Frogs disappear one by one. Confrontation, anger, desperate comic relief all ensue. As the list reaches its end the pace quickens, and the cameraman himself becomes a quarry. Then boots dangle from a noose. A female voice speaks as the camera studies an empty hallway:

> It's quiet now. That feels good. It was long, but it's over now. . . .
> I killed the first five quietly — Carole, Antoine, Anne, Michel,
> Diane — no one suspected. With my nine days in prison
> they didn't take me seriously. . . .
> There's just one more little thing to do. . . .
> I will be assassinated like the others. But I won't leave you
> the pleasure of seeing that. . . .
> (Camera closed down to black. A final gunshot.)

The tension, confusion, concern, fear were almost palpable. The guests had gone through the questions and sequence of deaths a dozen times, but found no motive, no clue save their own (past) guilt. "Calice, j'ai toujours mangé de la merde à cause des autres." And suddenly it was all over.

La réception is constructed like other tapes by Morin and Dufour. Unusual individuals, or those with unusual stories, are invited to "play themselves" in a situation similar to one from their own lives. In this case, Morin had met several ex-convicts, and had invited them to the house for the project. They hadn't known each other before, and were told only that one of them

was a murderer. Within this framework, dialogue and response were totally improvised; it is easy to imagine that the circumstances were volatile. With fatigue, uncertainty and the constant presence of the camera, anger and paranoia were inevitable. The isolated house and hothouse conditions felt more and more like another jail. They began to know each other, establish a "pecking order," *live* the story in a certain way.

To consult the Agatha Christie novel or play, however, is instructive. The structure of the original story is identical, with a mismatched group of individuals — each with a crime to hide — invited to a party under unusual circumstances. The "10 little Indians" of the original story are transposed to plastic frogs (a sly play on the French as "frogs" rather than Christie's "savages") and the actors playing a mix of generals, Bible-quoting spinsters, doctor, judge, rake and so on, are replaced by *actual* ex-convicts with *real* criminal experience, speaking a broad joual, laced with prison argot. This is a significant change, removing the whole from drawing-room comedy and instilling an impressive literality. In other respects, however, the action repeats Christie, as the deaths are accomplished by similar means, the dialogue follows a similar general pattern and dead-end clues pile up without ever pointing clearly to the culprit before the final admission. Even the recording introduced early in the play — a gramophone record entitled *Swan Song*, identifying the characters and crimes — is mimicked in the tape by the videocassette playback. As a multiple form of translation, the videotape shows fascinating differences and similarities. The fact that Christie herself had translated her popular novel into a stage play, changing the ending to maintain the surprise factor for her audience, is in itself pertinent. Three film versions of the play have been made, too, so here Dufour/Morin are again updating the quotation of "classic" popular culture.

The videotape was shot nonstop over nine days, and 17 hours of raw material were recorded. While shooting and dialogue were improvised, the final tape is — evidently — a sophisticated construction where choices have been made. Morin was responsible for the camera and Marcel Chouinard for sound; Colette Loumède managed lighting and a second camera, while

Lorraine Dufour supervised the whole, assured continuity and reviewed each cassette as others were being recorded. The only other assistance was provided by a "gopher" running errands. Time and tension were required constants, and these were rough customers, to be handled with care — and finesse.

La réception is a model work. Just as Gustave Flaubert's *Madame Bovary* (1857) proposed a single fictional portrait as emblematic of a complex social type, a microcosm of bourgeois ambition and desire, Morin and Dufour offer this whodunit as contemporary sociology. This company of felons is presented as a contemporary mapping of human interaction and motive, though hardly as an ideal. *La réception* is rife with revelations of character and sensibility, simultaneously an analysis and critique of society (both as pictured here in microcosm, and as *resulting* from the experience of criminal activity and prison). At the same time it is a sympathetic portrait of individuals (and their reactions) as they are trapped by circumstance.

Morin and Dufour have used very different points of departure in other works. The videotape immediately preceding *La réception*, for example, offers equal definition and comment from well outside Quebec society *and* geography.

La femme étrangère

"I think I was forgotten for years, and when finally a place had to be found for me, it was quite simply decided to send me to the beginning of time, here in the rain forest."[5] The clouds part to reveal a distant river and dark shore, seen from an airplane in the sky.

Change of scene. A woman sits in a dugout canoe, being paddled — then motored — down a broad river, and in voice-over we hear her story begin again. She is Helena Valero, 68 years old, and she is now blind. At 12 years of age she was carried off by the native Yanomami tribe, and held captive in the jungle for 24 years. She was taken as wife and had two children, but then her husband was killed, his death ordered by the Hekuras, spirits who visit the men of the tribe through the (hallucinogenic) drug *yopo*.

Having escaped at last she made her way to Manaus, only to be ostracized by her family for her Métis children. Valero has re-

turned now to the jungle, where she lives quietly with her sons and grandson, midway between the Yanomami and a settlement of white missionaries, for whom she acted awhile as interpreter. Helena Valero belongs to neither whites nor natives.

Sitting with her back to the river she begins a third time, going further back for details. The scene shifts to the Yanomami as they paint their bodies, then prepare and ingest the *yopo*. They play out the death of Fusiwé in the jungle, combining memory and present events before our eyes.

Within this 20-minute videotape are elements far from the traditions of either documentary or fictional narrative. There are compelling ethnographic elements, views of the Yanomami as they decorate their bodies and inhale the drug for which they have become known — its physical effects evident in their facial expressions, their adopting of animal voices, their dancing and chanting, the discharge of mucus, blood and vomit attesting to the drug's power. We see their large communal dwellings and smaller private huts, watch the women preparing food and the men working in the jungle to hollow out canoes. We see and hear what seems to be "daily life": the exotic (to us) made normal through the work of the (invisible) camera. We are visitors in the jungle, watching something that seems direct documentary material. Valero comments in voice-over upon what we are seeing — though she herself cannot actually see these scenes. "Here life repeats itself with such regularity that it is impossible to imagine the contrary. It's like a clock: after eleven o'clock, it's noon." What is depicted *now* is presented as *then*, with time collapsed, and Valero an implied participant in the events appearing on screen. We do see her as she rides in the canoe, enters her house or sits with others, but these scenes act as introduction and bridge to the action, while the highlights — the "ethnographic" material — depict "the same events" of 40 years ago, played out by Yanomami. The critical moments are *representations* of long-ago events. There are two "documents" intertwined here: the present and past stories of life with the Yanomami. However, they are not the same.

The Yanomami are one of the few native groups continuing to live in relative isolation from Western "civilization," though

their lives are threatened by the devastation of the Amazon forests and now by encroachments of other exploiters or would-be settlers. The numbers of Indians are dwindling rapidly. The years when Helena Valero first lived there (1932-56) relate directly to the pioneering studies of French anthropologist Claude Lévi-Strauss; he arrived in São Paulo in 1934 and conducted extensive expeditions in the Brazilian interior in 1938-39; the resulting book, *Tristes tropiques*, was published in 1955. Lévi-Strauss had been an early "invader"; in this tape we learn that Valero's first departure from the jungle was assisted by directions she received from outsiders cutting wood in the area.

With the example of Helena Valero, Morin and Dufour consider an experience far from their own in Quebec or other parts of Canada. Recalling the words of Lévi-Strauss again:

> Since we know that, for thousands of years, man has succeeded only in repeating himself, we will attain to that nobility of thought which consists in going back beyond all the repetitions and taking as the starting-point of our reflections the indefinable grandeur of man's beginnings. Being human signifies, for each one of us, belonging to a class, a society, a country, a continent and a civilization; and for us European earth-dwellers, the adventure played out in the heart of the New World signifies in the first place that it was not our world and that we bear responsibility for the crime of its destruction; and secondly, that there will never be another New World. . . . [6]

The Amazon jungle offers an image of the beginning of the world, and Lévi-Strauss was the founder of contemporary structuralist anthropology. Similarly, Helena Valero is an individual found at "the beginning of time," emblematic of a society in its purest "primitive" form. Dufour and Morin seek to reveal and understand the "normalcy" of the misfit, and Helena Valero is a figure caught between cultures, accepted by neither but part of both. She can thus function as arbiter, her experience as outsider illuminating both worlds.

This is one woman's story, told in direct narrative. She is the one who speaks throughout, often in the first person. Indirect narrative also has a place, in her description of past events and present activities of the tribe. When she speaks on screen (in

Spanish, or with words from other languages) sync sound is used, with a second sound track for voice-over narrative in French or English; the voice-over descriptions of "ethnographic" materials (or Valero's story told as if in reverie, without her speaking visibly on-screen) are in the narrator's voice only, though we continue to hear the direct sounds made by the actions or events on screen. All of the images were recorded on site, and edited together later; the lap-dissolves of her long "interview" next to the river make the cuts evident, but the match between her original words or movements and the voice-over précis-translation is carefully managed, so that even as the cuts are pointed out, they're diminished. Since Helena Valero is blind, direct eye contact isn't possible; what otherwise might seem an obstacle to suggesting her frankness and making the viewer complicit in this reconstruction of events, becomes a subtle tie instead. With her averted gaze, she seems open yet quietly determined. Rather than bitterness or resentment, we see her gentle resignation, even as she remarks that after Fusiwé's death, "I never again knew peace, nor tranquillity, not even today."

La femme étrangère was completed and released in 1988. Lorraine Dufour and Robert Morin had travelled to Venezuela some years earlier, in connection with different projects. They had read Ettore Biocca's biography[7] of Valero a decade or more before but had assumed she was no longer living; when their friend Emilio Fuentes, an anthropologist working near the area where she lives, mentioned that he could arrange introductions, they decided to try to meet her. Not so simple — with the drug wars and political turmoil in Colombia and Venezuela, the first attempts to reach her were fruitless. Eventually, however, they penetrated the jungle to meet and record Valero, and were able as well to try working with the Yanomami, whom they found to be willing participants and capable, precise actors.

The tape was originally conceived as a "demo reel" to raise money for a much larger, feature-length project, but grew into a powerful small work in its own right. It was the substance and implication of the images themselves (shot in 1987), and the personal example of Valero, that shaped this complex and subtle portrait.

The editing phase for *La femme étrangère* assumed a particular significance, as the piece could only be properly conceived after shooting was complete. As with *La réception*, there was no "second chance" for augmentation of the original footage. Lorraine Dufour acted as both producer and editor for *La femme étrangère*, as well as narrator of the voice-over text for which Morin had written a first draft. The territory investigated was both physically and psychologically demanding, and in a sense they really did travel to "the beginning of time."

STEPPING BACK

La femme étrangère has much in common with other tapes by Morin/Dufour. It studies a single individual as representative of — but misfit within — a culture. That individual is playing a part on screen, but the role assumed is one directly approximating her own life — in this case, the present/past tense conflation of herself with the Yanomami, but also the total replacement of her words *en direct* by a translated précis. She is interpreter not only of language but also of broader cultural issues. She represents the European colonial in an aboriginal environment, but is "native" in terms of Western civilization. What we watch is both documentary and fiction: an "as if" history in the present tense, where real tribesmen live out "normal" lives but also perform for the camera, and where the final result is a story not quite anticipated at the start. Dufour/Morin have tended more or less consistently to study the margins of their own society, to seek out individuals who throw their culture into relief by being well outside (or excluded from) the centre: dwarfs, circus entertainers, the mentally retarded or others in moments of internal confusion or change. Helena Valero can be seen as similarly marginalized by the events of her life. She is a figure of radical colonization — removed ever further from power and self-determination — first captured by Indians (taken from her own culture), taken as wife (into a traditional role of service), isolated by the tribesmen (who took away her husband), rejected by her original family (who denied her value as a mother, wife and daughter) and even by her blindness (which surely limited her field of

action). Now she is supported by her sons and by her temporary role as translator. Helena Valero acts as classic (blind) seer. She knows, though she can alter or prevent nothing. In the end, she withdraws into the night, where she is "the equal of others."

FICTIVE ANTHROPOLOGY

La réception and *La femme étrangère* play with traditional forms and expectations of fiction in both written and media-based forms. Both of these works were generated from published books and there is a certain literate quality to the narrative in each case. However, to compare the eloquence and expression of Helena Valero's biography/adventure with the rough blasphemy of the ex-convicts, or simply to consider the personality and history of the personages represented in each case, is to acknowledge the versatility of Morin and Dufour. The place of fiction differs as well, for while with Valero the *facts* were true and the *presentation* a construction, in *La réception* the story was a revision of known fictional material but the people — rather than being actors, accustomed to representation — were presenting *themselves*, after a fashion.

Through the realism of their portrayal, who-they-are is strikingly clear, but one may intuit, in their unguarded moments of emotion and response, who-they-might-have-been, given a different combination of education and social pressure.

This is the place of fiction for Robert Morin and Lorraine Dufour: in presenting an anthropology of the present, through a "framed" depiction of real people and actual problems or situations, they identify the construction of contemporary urban life. Individuals *are* briefly themselves, both private and public together, in portraits allowing neither sentiment nor censure.

NOTES

An earlier version of this essay was published in *Parachute* 62 (Spring 1991).

1 An exhibition entitled *Lorraine Dufour and Robert Morin. A Decade of Videotapes: 1980-1990* by curator Brendan Cotter opened November 1990 at A Space in Toronto, with a dozen tapes and a comprehensive catalogue. Included in the essays is a history of and productions by the Coop Vidéo de Montréal.

2 Claude Lévi-Strauss, *Tristes tropiques*, trans. John and Doreen Weightman (New York: Washington Square Press, 1977), p. 436. First published Paris: Librairie Plon, 1955.

3 *Ten Little Indians* by Agatha Christie was originally published in 1939 as a novel, and was the first work she re-wrote as a play. It opened in London in 1943 and New York the following year, having long runs in each case. When published in French, it bore the title *Les dix petits nègres*. (The 11 frogs of *La réception* refer to the cameraman in addition to the 10 guests.)

4 This and other otherwise uncredited quotations in the present section are my free translations from the spoken French dialogue of *La réception*, 1989 (77 minutes, colour) by Robert Morin and Lorraine Dufour.

5 All quotations in this section not otherwise credited are taken from the transcript in French of the voice-over text in *La femme étrangère*, 1988 (20 minutes, colour). This is my translation into English.

6 Lévi-Strauss, *Tristes tropiques*, p. 448.

7 Helena Valero, as told to Ettore Biocca, *Yanoama*, trans. from the Italian by Dennis Rhodes (New York: E. P. Dutton, 1969).

11

There's Something Perverse about This Relationship . . . [1]

A rtist Tom Sherman sits split-screen, talking on the phone; on each side of the screen is the same image from a slightly different camera position, as if he's in conversation with himself. In another shot he's alone in the shadows, flanked by a jade plant. Then he is seen eyes-only through a bright slit in an otherwise black screen, recalling Man Ray's surreal eye on a metronome. In still another shot he sits abutting the electric coils of a stove with cords, plugs, old-fashioned radio. Then he is framed by leafy plants in a softened ambiance: watchful, his face shadowed. The single quiet voice continues throughout. In all, he speaks on-screen for three hours, chosen from a recorded six.

> Our memory of this is exclusive. No one else will ever understand exactly what it is we share right now.
> I like to be able to be with you, fresh like this in the morning. I wonder how often you looked at the tapes last night. . . .

This is a fiction, a prose work in narrative form wherein the characters and incidents are wholly or partly imaginary. Though we seem to be engaged in conversation we cannot actually enter into dialogue: this is a prerecorded work with no possibility for

Opposite page: Tom Sherman in *Exclusive Memory,* 1987. Photo courtesy of the artist.

129

interaction. Sherman remains alone on-screen, speaking to the viewer.

But who is this "viewer"? As we gradually deduce from the narrative, the viewer is a machine, a robot learning the ways of the world. The stories Sherman tells are exemplary of the way humans function. He refers to his own earlier employment, and to recently having been in Nova Scotia with his family on holiday. Distant and recent pasts are presented alongside each other, memories all.

This is a performance requiring concentration and control. It is either a remarkably extended improvisation, or a fascinating exploration of the nature and content of recollection: a veritable ethics of memory. These stories appear to be true, and knowing the artist, one might confirm that the "human" stories are actual events within his personal biological memory. But what about "you," that is *us*, when we (apparently) walked down the beach together last summer? The robot—surely a convenient fabrication—was not walking. *We* were not walking. *This* memory is a fiction and so calls into doubt the other "memories" as well. Could *all* these memories be invention?

As he speaks, Sherman reiterates the "exclusive memory" of the tape's title. The events presented here are exclusive to "you" and "me," i.e., they are privately held between speaker and robot. They spring from a single source, and form a complete entity. Evidently, there is much that is left out of this *Exclusive Memory*. As viewers experience the tape they are also incorporated into the exclusivity of the memory being reconstructed. And indeed, that memory is (necessarily) constructed within the mind of the viewer *as it is* being assembled in the memory of the robot. The double form of memory and reality must merge in the tape: reality is presented or described as a sequence of memories, and memory as constituted in this monologue is in turn the only set of facts available to the robot or, finally, to the viewer. A politics of reception is being formed.

Tom Sherman is posing for the camera as "talking head," a scientific researcher, teacher and visitor to the university. This is his assumed on-camera role. Ostensibly, he is posing for the ro-

bot. He talks a lot about maintaining his static position to improve legibility. While he speaks to *you,* the robot, he knows that he will be heard by *us,* the audience. The now of speaking is taken to coexist with the now of listening, despite the actual dislocation in both space and time. He seems to establish an intimacy with his viewers, to maintain direct eye contact and return our gaze even though there is no place for literal reciprocity in the recording and viewing of the event on tape here. Video and television have always maintained both the capacity and the appearance of "live" presentation and Sherman plays quite consciously with temporality.

All the same, we know we are *not* actually with the artist while we watch this videotape, even though we seem to be regarded through the screen by the on-screen speaker. What we see before us is finite, but our own response is still being formed.

Christian Metz has proposed that the pleasure of narrative cinema resides in its gratification of one's desire to be "a pure, all-seeing and invisible subject, the vanishing point of the monocular perspective which cinema has taken over from painting."[2] When one considers video, the situation of the small screen and close viewing reduces the need for a roving eye, and the requirements of vanishing-point perspective alter in the overall reduction of scale and flattening of depth. Though TV sets at home continue to increase in size, the eye easily encompasses the entire image on a "standard" set (21 to 27 inches diagonally) at one glance — a return in one sense to the smaller easel painting. Still, in watching or experiencing video, the viewer remains all-seeing and invisible, even more a single eye, and this privileged and central viewing position is further underlined for this tape by the direct and constant address, one speaker to one viewer, which constitutes *Exclusive Memory.*

Sherman "displays" himself on screen. We are the central eye, he the object before us, a "sign" of meaning. He is the figure in his own extended peep show, playing (at least in part) a passive role. Yet we may come to feel HE is the one who watches: reciprocal voyeur. He acts here on the fetish object — a machine

with a memory — to fill it with information. He accepts the robot as desirable, malleable and enviable:

> I can go that way. I can think of myself as a robot. . . . If I have to think of my eyeball as a lens, with some electronics behind it, I'll try to think that way. I'll try to think about what I'll do with the images I collect. The images I collect are all permanent in a certain way. The people around me seem to be obsessed with disposability. I don't think that any of the images are disposable. I think we've fooled ourselves. If I'm a robot, everything I see I'll remember, everything I see I'll record.

Juggling with the tradition of active-male-viewer and passive-female-image, Sherman poses on-screen for hours and one may note the play of concealed humour and affection, wariness and fatigue in his eyes and voice. There is the constant impulse to assess the validity of his appearance, his words, his construct. For this purpose, Tom Sherman is also "the artist." He tells us bluntly that he left the employ of the government to spend more time with "you": the robot (and) the machine world (and) the viewer. He wanted perhaps to claim his artist-self, private and inner-directed, from the administrative one he had been inhabiting as a public servant. This is a defensive manoeuvre, returning to an inner core in order to affirm that that core remains intact and accessible. However, the act of making this particular work is an aggressive gesture, for he makes "you," the viewer, a robot — a machine to be directed — and tells presumably more about "himself," past and present, than one could ever have known had he remained the public bureaucrat: manipulation by inundation of information.

As Craig Owens has pointed out,[3] posing is a form of mimicry, and entails a certain splitting of the subject: the entire body detaches itself from itself, becoming a semblance or picture. Owens cites Jacques Lacan's reference to mimicry as a "separated" image: from *se parare, se parer*, "to dress oneself, but also to defend oneself, to provide oneself with what one needs to be on one's guard."[4] (Here, Sherman presents himself simultaneously as scientist and artist, programming a familiar and accommodating robot). Lacan considers mimicry or masquer-

ade — simulation and seduction — feminine, compensation for a lack of masculinity and the phallus. This is a psychoanalytic notion much in currency. (Sherman's act of authorship — maker of meaning — is surely undercut by his repeated verbal submission, his willingness or desire to become identified with and taken over by the machine that listens and watches. This is a pose for and seduction of the audience). The gaze objectifies and immobilizes what lies before it; what falls prey to the gaze naturally freezes (in defence) in the pose. For Lacan, what is involved in the scopic drive is making oneself seen (*se faire voir*). The activity of the drive is concentrated in this making oneself. "In other words, the subject in the scopic field, insofar as it is the subject of desire, is neither seer nor seen; *it makes itself seen*. The subject poses as an object *in order to be a subject*."[5] The words of Lacan via Owens seem a good description of Tom Sherman's position in *Exclusive Memory*.

The case was somewhat different in an earlier, comparable tape. *TVideo* (1980) was made for broadcast on cable, and is a half-hour monologue addressed to "home" viewers — as opposed to a gallery-going public which actively seeks out works of art. He identifies himself by name, describes a daytime routine, details various illnesses and discomforts and twice mentions in a weary voice that "by the time you see this I'll be dead." A clock figures in every interior, and references abound to the passing of time. *TVideo* interlaces "truth" and "fiction," and in so doing rehearses a sequence of activities perhaps similar to those of the viewers themselves, passing a day at home alone or returning there after work or errands. It seems to refer to the daytime television of self-help programming and talk shows, and to act on assumptions made by their viewers. When *TVideo* was aired, the station received several anxious calls inquiring about Sherman's health; clearly, a certain identification with the audience had been achieved. There seemed little recognition that the work was fictional and theoretical; perhaps the visual and verbal information of the piece seemed literally too mundane to have been an intellectual construction.

The viewer of *Exclusive Memory* is specifically designated as *robot*. What or who is this robot? — a machine with no previous memory and thus no experience or judgement, it records everything received from the artist, and nothing else. It is an acquiescent "perfect" companion. As *Exclusive Memory* progresses, Sherman seems to fall under the spell of the robot, responding as if to a female presence. As Virginia Woolf so ironically observed, "Women have served all these centuries as looking-glasses possessing the magic and delicious power of reflecting the figure of a man at twice its natural size."[6] Here, Sherman seems another Pygmalion, that sculptor who fell in love with his creation (his statue) to the extent that Aphrodite, taking pity on his torment, brought the figure to life as Galatea.

> Right now I'm streaming into you. I'm pushing things into you. I feel like I'm being pulled by you into your memory, but there's very little reflection. I need some reflection back to more adequately see what's going in there. And that's why I was so pleased to see the response on the screen. . . .
>
> My whole way of looking at the world is changing, because of you. I like what's happened. I like the way it's changing. . . .
>
> Sit back. Relax. The pattern has motion. A nice pace. Your tripod's stable. Don't worry about a thing. Just sit back, relax, the pattern has motion. I'm looking inside of you. I'm looking inside of you. I feel that I'm reaching something. I feel that there's a completion. I feel that there's a zone around us. An unbroken zone.

Though Tom Sherman is seen here alone, we are not allowed to forget the presence of the video camera. The recording machine and simultaneous image seen in real-time on the screen have freed him from depending on an organic memory, and given him a "companion" to which he responds. Considering its properties and capacities, he speaks directly into the lens: "You have to understand that human memory is connected to smell. Memory and smell are connected in mysterious ways. I can smell tape right now. I can smell tape and it makes me think about the experiences I've had." Sherman has posited the camera (eye) and recorder (memory) as prime recipients of his words, in the persona of this robot. Although the image the viewer sees (later,

after editing) in the finished piece remains a multiple one, two or three elements fused on-screen, the picture Sherman sees on the monitor in real-time is a single one of his face and torso, as if a mirror. He considers it thoughtfully and at length while recording, using that figure as spring for inspiration. Quite correctly, feedback: the return of part of the output of a system into the input for purposes of modification and control of the output. So Sherman speaks to himself in the present — an opening to narcissism and self-reflection, as it were — with full intention of its storage against a foreseen future. Yet his words still seem directed to a comforting, nurturing, fascinated female presence:

> I feel so safe here.
>
> Somehow leaving my body through this relationship is giving me a much greater sense of my place in the scheme of things. I think that ultimately that might be the gift that you're giving me. You're so kind in your level of attention. You don't demand an awful lot. There's still that pull there. There's still the seduction to start with. And when I cross over into you the flow seems to feel natural in a way that I haven't used the word before. You're so still. And you're so attentive. It's like the old cliché "the wheels are turning." Your wheels are turning.

(What I have called) the pose of Tom Sherman is extended on screen for three hours, though the ambiguities and uncertainties of subject-object / male-female in confluence here are by no means the only issues to be considered in this work. One is the more conscious of Sherman's surface image through his consistent halving or tripartite division of the screen, where each of the nine main sections is heralded by a brief montage of multiple images and a sequence of squealing sounds recalling animal anxiety or a mechanical jamming. None of this is by chance. Equally, one could investigate the numerous references to less psychologically charged data, in his discussion of machine intelligence, motion and pattern recognition, peripheral vision, television aspect ratios and dark-light readings. Sherman's eschewal of colour implies a desire to reduce the physicality and retinal appeal of the on-screen image and its reference to television or ad-

vertising, just as much as making reference to the customarily monochromatic computer screen.

We, watching this videotape, are Other. The robot as postulated receiver for Sherman's words and images is equally Other. Throughout *Exclusive Memory* one finds oneself attempting to get to know Robot; does Sherman intend to speak to me (that is, the viewer, now) when he addresses Robot? How much of his monologue is taken from personal history; in what way does fiction form a part of that same personal history? Indeed, is any history a fiction — a narrative of one-thing-after-another entirely manageable from the present? George Orwell reveals the perfection of "reality control" in his discussion of doublethink in the novel *Nineteen Eighty-Four*:

> But where did that knowledge exist? Only in his own consciousness, which in any case must soon be annihilated. And if all others accepted the lie which the Party imposed — if all records told the same tale — then that lie passed into history and became truth. "Who controls the past," ran the Party slogan, "controls the future: who controls the present controls the past."

> At all times the Party is in possession of absolute truth, and clearly the absolute can never have been different from what it is now. It will be seen that the control of the past depends above all on the training of memory. To make sure that all written records agree with the orthodoxy of the moment is merely a mechanical act. But it is also necessary to remember that events happened in the desired manner. And if it is necessary to rearrange one's memories or to tamper with written records, then it is necessary to forget that one has done so. The trick of doing this can be learned like any other mental technique.[7]

We feel "included" in the subject-object exchange of *Exclusive Memory*. Perhaps this comes in part from the physicality of response customarily demanded by the video medium: while television may leave intellectual involvement aside, the attraction of its glowing presence is undeniable. McLuhan called the medium "cool," its paucity of visible information demanding the viewer's (unconscious) effort to fill in image area. Sherman's words are

similarly cool. The combined result is "a work in which certain parts are visible while others are not, in which the visible parts render the others invisible: in which a kind of rhythm of emergence and secrecy sets in, a flotation line between the imaginary and the ostensible."[8]

Tom Sherman is also a writer. He understands hyperbole and black vision, knows scars and the inevitable presence of decay — all rehearsed in *TVideo*. His fantasy is no image of beauty, and escape is likely to be medicinal or hallucinatory. His musings may also be seen as instructive, reflections on the state of the world:

> Sit close up and watch the scanning roll. Look into the surface of the screen and feel the radiation of beautiful light. We have so much control over light. Slick camera control of light and shadow. Sit closer and watch the picture form. Turn the sound up loud and turn the lights down low. Sit up in bed like a baby in the television light. Try to follow the switching being done for you at master control. Watch the bad edits tear. Notice the way the programmes fit together. See the way they chop in those commercials. Sit so close, you can't follow the action. The edits come too fast this close. Turn the channel selector. Turn it again. Turn the contrast up. If you have a focus control, turn it so the image is grainy. Toughen up the image. Just a touch of fine tuning to straighten the sound out. Now place your nose on the glass of the screen. Press your face on the screen. Keep your eyes open. It's beautiful up close. You can feel the charge on your face. You can sense it when you close your eyes. The cool light is red inside.[9]

Video is no mirror but it offers a particular "as if" image: as if television, as if live, as if permanent, as if central to current technology. A talking head which speaks to us from a TV screen is neither a painting nor a poem. We receive it as a direct message. Television has been companion and influence for a long time now, part of our "real" life, and Tom Sherman's *Exclusive Memory* makes that territory his own.

Notes

1 This essay was written in 1989 and first published in *Parachute* 58 (Spring 1990). It has been revised for publication in this volume. The title quotation and all other uncredited texts are transcribed by myself from Tom Sherman's three-hour black-and-white videotape *Exclusive Memory*, produced while artist-in-residence at The Western Front in Vancouver, 1987. Sherman's original plan for the work was as part of a museum or gallery installation, where the videotape would be accompanied by additional video and painting elements; it has been purchased in this installation form by the Vancouver Art Gallery for its permanent collection.

2 Christian Metz, *The Imaginary Signifier: Psychoanalysis and the Cinema*, trans. Celia Britton et al. (Bloomington: Indiana University Press, 1982), p. 97. I might point out as well that your reading of the present text offers a further single-point perspective: a single reader for a single writer, thus further extending the chain of "seers."

3 Craig Owens, "Posing," in *Difference: On Representation and Sexuality* (New York: The New Museum of Contemporary Art, 1984), p. 15.

4 Owens quotes Jacques Lacan, *The Four Fundamental Concepts of Psychoanalysis*, trans. Alan Sheridan (New York: W. W. Norton, 1978), p. 214.

5 Owens, "Posing," p. 17. Emphasis in the original, following quotation from Lacan, *Four Fundamental Concepts*, p. 195.

6 Virginia Woolf, *A Room of One's Own* (Harmondsworth: Penguin Books, 1945), p. 37.

7 George Orwell, *Nineteen Eighty-Four* (Harmondsworth: Penguin Books, 1954), p. 34, 183.

8 Jean Baudrillard, "What Are You Doing After the Orgy?" *Artforum* 29, 2 (October 1983): 43.

9 Tom Sherman, "How to Watch Television," in *Cultural Engineering* (Ottawa: National Gallery of Canada, 1983), p. 56.

Afterword

The foregoing, rather than presenting a comprehensive history of the video medium, is a scrutiny of individual works by artists, and an attempt to cast light on certain aspects of a developing language. The bulk of these writings date to the mid-1980s, a moment of "first hindsight" for the investment in what I identify as "narrative" in video. (I have chosen not to discuss the nonnarrative and anti-narrative tendencies which came into being in the same period). Experiments with narrative developed to some extent out of *explanation*, a talking-to-oneself, a turning inward in search of answers to questions that were not yet clear. Beyond a stringing together of words, other less familiar evolutions for the production of meaning demonstrated a desire to open new intellectual and emotional terrain generally. New histories were being enacted, a replacement for the unsatisfactory past and present. Such investigation had begun a decade earlier when the newly available, consumer-grade video camera and monitor were taken up by artists at a moment of hiatus in the avant-garde. Painting and sculpture, the traditional system of dealers and galleries, collectors' and museums' stockpiles, seemed bankrupt and irrelevant, the production of objects-for-sale, a sorry aspiration for the creative individual. There was a yearning for something well outside of a hands-on crafts aesthetic or a plan for social and financial success. The visual arts opened to an uncertain future state, still unnamed and uncertain in the early 1970s.

Video, in part, was simply a new toy with neither rules nor a trajectory of development — one of the many options coming forward. After a few months or years video was dismissed by many but — for those it suited — it was pursued with a growing interest and commitment. There was evolution and change, both

in the technology and in the ends to which it was directed. Now, in the mid-1990s, there *is* a history for work in this medium and a much-changed context, including new crossovers between media that are blurring boundaries and shifting definitions for time-based work generally, both in art and popular entertainment. The original innocence of the first artists working with the medium is quite replaced. Speculative writings of only a few years ago (especially for developments in, and diffusion of, hardware *and* audience) now seem amusingly utopic — either banal common knowledge, or naively futuristic and wrong-headed. It is misleading to conflate the concerns of art and commerce. While business will tend to see the arts as marginal, consumable entertainment, a "product" for sale, the artist may lead conceptually, though not in practical terms. To those who remain outside the commercial system, who are neither on staff nor on call, access to the means of production and distribution in mainstream media is virtually never available. Industry may look to artists for research and development options, but usually, artists must work in relative isolation and delay deployment of their ideas until equipment has come down in price, or is accessible by alternate routes. Distribution and audience remain as elusive as ever, when populist and popular forms — and big-money backing — are not sought at the outset. When an idea is investigated for its own sake, for curiosity, for an intuited personal growth, there is seldom an immediate external reward.

For the broader view, as Jonathan Crary has pointed out,

> Telecommunications is the new arterial network, analogous in part to what railroads were for capitalism in the nineteenth century. And it is this electronic substitute for geography that corporate and national entities are now carving up. Information, structured by automated data processing, becomes a new kind of raw material — one that is not depleted by use.

Further, "The convergence of the home computer, television and telephone lines as the nexus of a new social machinery testifies to an undoing of the spectacular consumption of the commodity."[1] There can be no doubt that such developments have impacted now on the relationship of artists to media-based tools

and language. Available recording and postproduction equipment is more sophisticated and more easily handled than ever—though naturally more expensive for regular rental or (heaven forbid) purchase. Options for distribution are potentially unlimited: tapes on loan through the local library, 500-channel televisions and international satellite delivery, pay-per-view at home via telephone and fibre optics, a cable system so ample that broadcasting is outclassed and outnumbered by *narrow*casting. It all seems as simple as the ubiquitous fax machine, though these toys remain just slightly over the horizon, their future uncertain. The artist's position, too, is yet to be negotiated.

These essays, then, coincide with stages in the development of artists' use(s) of machines and new ideas, their changing relationship to a context of contemporary art and culture. The essays deal with a present tense, always in flux, an interaction open to question, manipulation, adjustment. With an enormous number of tapes and installations from which to choose, the decision to select and study just a few works in some detail seemed natural as a means of opening other doors, and charting an intellectual terrain. In each case—Askevold, Cohn, General Idea, Morin/ Dufour, Sherman, and others—the work chosen offered resistance to direct reading, revealed a *strategy* on the part of the artist that seduced and refused simultaneously. Surface appeal, both visual and textual, shrouded prior agendas that demanded investigation, further time and thought; each posed a puzzle whose solution redirected the avenue of inquiry. It might also be seen that critical tools and concerns were developing along with and in response to artists and works. Colour, image quality, postproduction possibilities and special effects, computers and changing formats, more nuanced sound reproduction, even the size and luminosity of monitors, all introduced additional issues to the discussion. Changing social concerns, issues of race, sexuality or censorship had an impact in all the arts, as art for art's sake (aesthetic, formal and conceptual proposals) was largely being replaced by a sought-for social *relevance* in the mid-1990s. The context of activity and publication in other visual arts areas is also relevant in this demand for conscience; new works built

upon and responded to what had gone before. Intellectual issues were now seen as political, with the potential for *making a difference* in the broader world. Audiences continued to change. Video was not "boring" any more, at least not in the same way, or for the same reasons. Everything was always still in motion.

In seeking answers to the "what" of the achievement in these works, the "why" of response has faded in and out of focus. Literature and psychology have indicated points of entry—but video is not literature, and psychology is not art. While elements may be abstracted from these comprehensive and fertile disciplines, the fit is incomplete. Again and again narrative issues surface in these tapes, but "narrative" itself is fugitive, shifting, slippery as fiction or experience or "reality."

Narratives are verbal or written accounts. They may be acts of storytelling, and may accompany and explain visual representation, including drawing, painting or slide sequences, film or television. But there are additional, nonverbal narratives, harder to identify. What of *sequence* on its own? Narrative requires duration, though end and beginning and middle may appear partially or not at all. All middle is more common than all beginning or all end; though one does love to know "what happens" conclusively, closure is no requirement, however traditional. If a picture is worth a thousand words, what of a 30-second sequence, something the size of a regular commercial advertisement on television? Stan Douglas of Vancouver has created a dozen *TV Spots* (1988), and almost as many *Monodramas* (1991), most without closure yet all quite satisfying narratives on this scale. Norman Cohn, in his studies of deafblind children, or individuals in a Newfoundland "old folks" home, manages to indicate complex emotions and life histories with never a word spoken. These are narratives too, though the artists' intentions differ widely. Douglas, well versed in the history of cinema and TV, builds *critique* at the core of his work—but at the same time is interested in looking at the supposedly "inconsequential": thoughtless moments where habit takes over to reveal fundamental personal and cultural assumptions. His abbreviated interventions are inserted without comment or explanation between the regular pro-

grammes of late-night TV—to a highly mixed response. Cohn is less concerned with media critique than with challenging a society too ready to categorize individuals by age, abilities or institutional role. Neither Douglas nor Cohn sees the "art" audience as an ideal one, though both appreciate the special perception that such conscious attention can provide; both artists have sought out a more generalized audience via television, certain that the "message" content of their work will be revealed there with less dismissal on the part of a public who assumes an artist's main concern to be formal values and "self-expression." Neither artist, however, has made concessions to so-called popular taste and the traditions of commercial television; their works bridge the two worlds (the mixed audiences) uneasily. As above, the work is resistant to direct reading, resonant with strategic underlay.

A sequence of images placed side by side tends to suggest narrative authority. Images of eyes in closeup appear to "see" the next image following, whether nearby or distant, whether person, place or event. Dreams and imaginings may be suggested by juxtapositions of audio and visual images. They are *facts* as they appear. Leaps of logic may, through repetition, offer both pleasure and familiarity. Indeed, through practice, visual sophistication may be as extended—stretched, probed, prolonged, broadened, deepened—as musical or verbal experience and accomplishment.

Narratives may run counter to each other: verbal, visual, referential, historical. Insinuating images are shown with challenging text in Kate Craig's *Delicate Issue*. The near soap-opera qualities of Zacharias Kunuk document a vanished (but remembered) way of life: while we follow a group of Inuit families through the duties and pleasures of daily life, personalities and relationships have but little importance relative to the imperatives of climate and history. Yet the remarkable images—*being there* for a caribou hunt, or building an ice porch on a stone house—are not those recorded by careful anthropologists or a *National Geographic* team. One is always *inside* the action, surrounded by kids and dogs and casual adult conversation. The "dailiness" of life depicted on screen is always seen (for viewers accustomed to

network television and urban living) against the radical "other" of our own assumptions, now strikingly revealed as limited, possibly smug.

For a quite different kind of juxtaposition, there is edited and assembled *found footage*, with commentary applied later. Text may have little to do with images appearing on-screen, as in Gary Kibbins' *The Long Take*, where short film sequences (the famous Zapruder footage of J. F. Kennedy in Dallas, a photographer with his model, a 19th-century hanging, a pair of praying mantises mating, laboratory footage of cell growth) are strung together against four voice-over readings titled "Film and Death" (adapted from Pierpaolo Pasolini), "Sex and Death" (with text from Georges Bataille), "Death and Law" and "Sex and Law." Viewer response is by no means dispersed by this variety: image and text do not clash so much as redouble their effect, making reference to state control, socio-cultural programming and interpersonal and institutional assumptions and demands. Juxtaposition leads to reverberation in the mind, a ricochet of ideas and deductions.

One might turn again to consider the intimate revelations, stories from life, of Lisa Steele's early work, or Vera Frenkel's metaphorical sleuthing, her elaborate constructions of political intrigue and historical determination. In documentary productions of another sort, like the fictional lecture constructed by Tom Sherman, or the "ethnographic" studies of Robert Morin and Lorraine Dufour, even the recording of private performances, as in Colin Campbell's early work, the text spoken may *indicate*, but it does not delineate the issues being addressed. In all these works, the viewer is an active participant but at one remove; though the tape is already existing (prerecorded), it appears to unfold in the "present," for video continues to recreate its aura of time suspension, most strikingly for works of the early days when there were more loose ends, less high polish. Invisible to artist/protagonist but in communion with the images on screen, the viewer performs a role during replay, reconstructing and interpreting events being played out "now." The viewer for these works is no passive receiver, a couch-potato looking for di-

version and loss of self; through attention and response this viewer engages directly with the work, participating in the making of meaning. The artists' early search for *explanation*, that talking-to-oneself that led finally to so many forms of narrative invention, is at work here still.

One does well to consider off-screen context as well as on-screen content. The subject matter and approach are self-generated and private (or collective), rather than corporate or mass-produced. The works are discrete — not a series intended for corporate profit and seasonal reruns. But given time and resources, any approach is open for assimilation. Since the 1970s, indeed, there have been many exchanges of form in the uses of pacing, text and image, between art and commerce in the electronic media. General Idea's *Pilot* was a precocious example for the art-side, and new angles for ads an excellent indication of the other. Neither art nor commerce wishes truly to become its opposite, only to diversify and supplement one's traditional sources of approbation and support. To TV or not to TV is not an issue.

These essays do not constitute an argument for or against the history of video. They reflect an earlier moment in hindsight, and place the developments in artists' visual language in what has become at centre a history of video's direction and change; they identify and probe the nature and role of narrative in Canadian video, especially as it developed in the 10 years or so following 1974. Conceptually and geographically a specific range of works, they have nevertheless prepared the ground for a multiplicity of current developments.

NOTE

1 Jonathan Crary, "Eclipse of the Spectacle," in Brian Wallis, ed., *Art after Modernism: Rethinking Representation* (New York: The New Museum of Contemporary Art, 1984), p. 286, 287.

APPENDIX

THE EARLY YEARS

The first low-cost, portable, consumer-market video cameras recorded only in black and white, on half-inch open reels. Editing was so unreliable that it was rarely considered, "real-time" being the approved norm. Operating first in a spirit of non-commodity, anti-television, anti-gallery/museum, video was a means of capturing the "ephemeral" and "insignificant," looking more closely at the hitherto unnoticed, while avoiding altogether the customary power relationships of the art world.

Most work was improvised for the camera, or collected fortuitously. It was the moment when Conceptual Art — whose focus was idea or process rather than product as the "real" art activity — shifted towards Performance and Body Art. Video documentation of these often-private actions, conceived as sculpture using the living body or natural landscape, was often the only record of their having taken place. Artists of the late 1960s and early 1970s welcomed the new tools, for all categories as such were open to question.

WORDS

Certain terms continue to appear, but the meanings which accrue or are applied may be particular to the medium or period.

"Personal," for example, is a term relating to what has been called "underground film" beginning in the 1960s: "personal cinema," i.e., independent film works produced outside the commercial system, self-financed, of nonstandard length (neither "shorts" of 10 minutes nor 90-minute "features") and with content often highly subjective, autobiographical or intimate. They might investigate the properties of the medium itself, and its philosophical underpinnings. These films were and are personal

in the sense that they are made by an individual for an audience willing to view them on the artist's terms; they are not aimed at commercial general release at the neighbourhood theatre, or for educational purposes, nor are they "industrial" films for information/training profiles or use in industry. Most often screened in cinemathèques with other artists and filmmakers as audience or even more, in college history-of-cinema courses, personal or experimental films are a form of research-and-development outside the commercial mainstream.

In the early to mid-1970s this term "personal" seemed to apply equally well to artists' video, for similar reasons. The works were produced alone, most often as private protest against commercial television. The audience at that time was usually of the milieu itself; the work was personal in that it concerned the particular individual who was author of the piece. In those early days, video often dealt directly with the person (body or psyche) of the artist him/herself and thus was literally personal, revelatory or investigative. More recently, with emphasis on post-production and the intended expansion of audience, video in some cases has moved away from investigations of body and medium, towards a form and content commenting on the same commercial milieu that had previously been rejected. The look is polished, more obviously aimed at an exterior or general audience. Though still intentionally distant from the commercial requirements of television and its something-for-everybody mindset, video has nevertheless changed significantly since its inception. The term "personal" no longer seems so central to the field.

To a certain extent this shift mirrored the broader arts scene of the time. As the return in the 1980s to heroic large-scale paintings — expressionist or abstract — confirmed the importance of dealers, collectors and return-on-investment, so a fascination with mainstream TV formats and technical polish flirted with commercial appeal. Yet there remains an important current of self-absorbed "personal" works, most especially those concerned with sexuality and relationships, which might nevertheless revel in lush imagery — both visual and aural — and sophisticated recording and editing technology.

"Communication," as a term, adhered in a similar fashion to early discussion of media issues. While the word stems from the Latin "communis" (common) and from "communicare" (to make common to many, share, impart, divide), it has come especially to signify the transmission or exchange of ideas and information. In the plural, it indicates a telegraph or telephone system as means of transmitting messages, or the study or science of communicating. "Communication," especially in the 1960s and particularly with reference to the ideas of Marshall McLuhan, had everything to do with television and what he called the "global village." The ideal of sharing and exchanging information and ideas, rather than one-way transmission, was paramount, and informed much of the thinking about video and social activism at the time. With the passage of years, however, the "mass" aspect of communications has come forward in the public conception and in the minds of artist-producers as well. Communications (now construed as singular) seems more closely associated with "empires": multinational companies controlling newspapers, satellites, film production (with cassette distribution to the home market), television and newspaper consortia on an enormous scale. Personal "communication" as correspondence or an exchange of videotapes seems private to the point of irrelevance — or a relic from the 1960s. But privacy and fantasy were a crucial part of early video.

INDEX